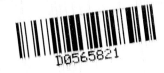

ESSENTIAL SKILLS FOR
NATURE
PHOTOGRAPHY

Cub Kahn

AMHERST MEDIA, INC. ■ BUFFALO, NEW YORK

Published by:
Amherst Media, Inc.
P.O. Box 586
Amherst, NY 14226
Fax: (716) 874-4508

Publisher: Craig Alesse
Project Manager: Michelle Perkins
Senior Editor: Frances J. Hagen
Assistant Editor: Matthew A. Kreib
Photos by: Cub Kahn

ISBN: 1-58428-009-3
Library of Congress Card Catalog Number: 99-072171

Printed in the United States of America
10 9 8 7 6 5 4 3 2 1

This book is dedicated to my teachers, who have helped me understand what is known, and to my students, who have helped me understand what is possible.
Thank you kindly.

About the Author:

Cub Kahn is a professional nature photographer and environmental educator. Cub's medium-format and 35mm photography focuses on the landscapes and ecology of mountains, rivers and coastal landscapes.

Cub's photos have been published in magazines such as *Audubon, Backpacker, National Wildlife, Sierra,* and *Travel and Leisure,* as well as *The New York Times* and *The Los Angeles Times.* His photos were featured in the book, *Virginia on My Mind,* and the booklet, *Virginia's Waters.* Cub has also written about nature photography for *Photographic* magazine. He has taught nature photo workshops and short courses since 1986 for a variety of environmental organizations and educational institutions.

Cub has degrees in environmental and marine sciences and a doctorate in education. In addition to his photographic pursuits, he teaches environmental sciences at Marylhurst University. Cub lives in Forest Grove, Oregon.

Grateful acknowledgment is made to David Cavagnaro for permission to reprint excerpts of his writing from *Feathers,* © 1982, Graphic Arts Center Publishing Company.

Table of Contents

Part Four
Beyond the Basics

The camera has kept clear an opening between my inner self and the natural world. Through this little window I can still sometimes see with the clarity of a child's eye and achieve a sense of oneness with the life and elements around me.
— David Cavagnaro

Introduction

"Nature photography is a fun, rewarding, creative activity."

Nature photography is a fun, rewarding, creative activity. More than that, nature photography is a powerful way of connecting with, and learning about, your environment. As a result of vast improvements in cameras, lenses and film, taking good nature photos is easier than ever.

This book is a guide for beginners who want to take great nature photos with color film and an automatic 35mm SLR or a point & shoot camera. Additional information is given for readers with manual SLRs who want to improve nature photo skills. This book covers the fundamentals of nature photo composition, exposure and focusing; specific techniques for photographing wildlife, landscapes and close-ups; basic information about nature photo equipment and suggestions for what you can do with your favorite nature photos.

To aid your learning, terms appearing in boldface type are defined in the glossary at the end of the book, and exposure and lens information is given for many of the illustrations.

To make great pictures, you don't need a lot of equipment and you don't need to memorize a bunch of strange equations and technical details. All you need are a basic camera, some simple guidelines, your own intuition and a whole lot of patience.

Most of all, good nature photography is a matter of spending time outdoors, observing nature closely, and learning how to best use the capabilities of your camera, lenses and film to make memorable images. You can do it!

Nature Photo Fundamentals

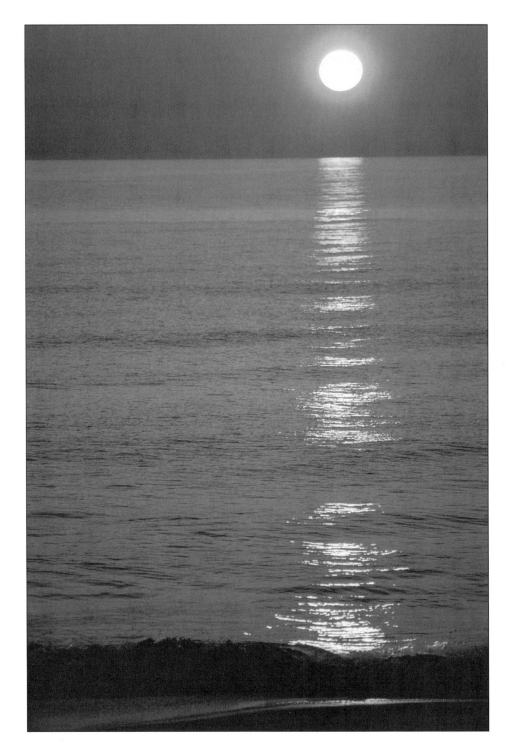

Composition

What is Your Message?

Photography, like sketching or painting, is a form of two-dimensional art. However, a painter begins with a blank canvas and fills it in, whereas a nature photographer begins by viewing the immense natural world and then selects a relatively tiny portion to record on film. Each time you take a nature photo, you are pointing your camera at some selected part of the earth or sky and thus you are composing an image.

What is meant by composition? **Composition** refers to the arrangement of visual elements — shape, form, color, tone, pattern, texture, balance and perspective — that makes up an image. Sounds complicated, doesn't it? Well, not really.

Taking a good photo is a lot like telling a good story. A simple, effective approach to composing nature photos is to look through the viewfinder and ask yourself two questions:

1. What is your message?

2. What is the best way to get that message across?

Why are some photographs of the natural world so compelling? Because the message is clear, the photographer did an effective job of communicating that message, and the message is not weakened or obscured by distracting elements in the composition (see photo on opposite page).

Simplicity

Many professional nature photographers take a rather Zen-like approach to composition. Rather than trying to stuff a bunch of subjects into a single image — maybe a soaring bald eagle, a grizzly bear with a salmon in its mouth and a beautiful sunset — pros learn from experience that simplicity is often the best approach when it comes to composition. Yes, the quality of your photos depends on

Opposite page: Try to compose nature photos that speak clearly to the viewer. This tranquil image of an Atlantic sunrise on the Virginia coast is visually powerful in its simplicity. (70-210mm zoom lens)

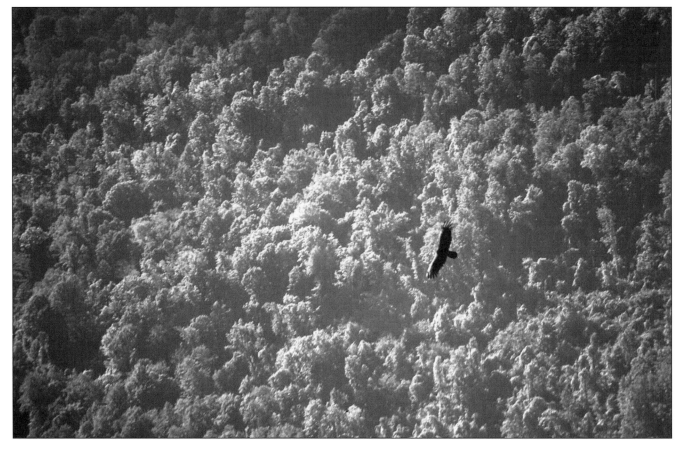

1-1: This photo of a soaring turkey vulture was taken in the Appalachian Mountains. It epitomizes simplicity in composition with a solid figure moving across a softly textured background. In photos of moving wildlife, frame the photo so that you give the animals plenty of room to move across the image. (70-210mm zoom lens)

what you put in the image, but keep in mind that what goes in the image directly depends on what you choose to leave out. Many poor photos are mediocre because the photographer's message is diluted by distracting details.

As you compose your photos, keep in mind the words of Henry David Thoreau, the 19th-century philosopher and champion of the natural world: "Simplicity, simplicity, simplicity!" A good approach is to keep looking through the viewfinder and fine tuning your composition until you have removed all unnecessary clutter from the image. Imagine that you are "cleaning up" your images, removing all the unwanted visual elements that can distract the viewer from your message (see photo 1-1).

How long does it take to compose an excellent nature photo? Maybe 45 seconds or maybe 15 minutes or maybe even longer if you want to make a really superb image. The great landscape photographer Ansel Adams was known for spending many hours or even days composing a single scene. And his world-renowned photos speak for themselves. Slowly and meticulously composing photos in the field can be a wonderful meditative experience.

Fill Up the Frame

Make your compositions powerful, make your messages clear, make your photos sing. Consider everything that is in the image you see through your viewfinder. Fill up the frame! Just as a land-

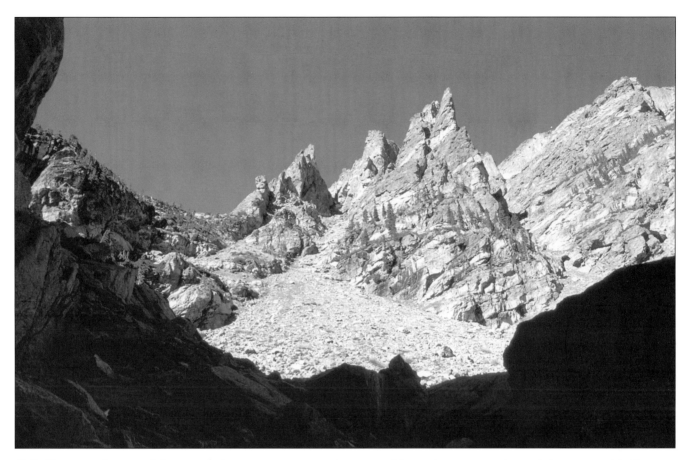

1-2: Once you have settled on a photographic subject and roughly lined it up in your viewfinder, try moving your camera left, right, up and down to see if you can improve the composition. Notice how this rugged Rocky Mountain landscape is framed by the shaded area in the foreground. (28-70mm zoom lens)

Quick Tips
Don't always take horizontal shots — improve your photos by composing and taking vertical images as well.

scape painter would not leave a portion of the canvas blank, you should not ignore any portion of the scene that you frame in your viewfinder. Make the best possible use of the entire "canvas" for each photograph (see photo 1-2).

Photographic compositions are weakened when important subject matter is too small to see. In many cases, you can significantly strengthen a composition by zooming in as much as your lens allows or, if possible, getting closer to your subject. For every nature photo in which the main subject is too large (a rarity), there are probably 50 photos in which the composition is weak because the main subject is too small.

Vertical or Horizontal?

Another way to improve your photos is to keep in mind that you can choose either a horizontal or a vertical composition. Because of the way many controls are conveniently located on the top of your camera, most people have a tendency to take far more horizontal photos than vertical photos.

The fact that most people have watched thousands of hours of television on horizontal screens — whose proportions are very similar to a horizontal image on 35mm film — likely increases the tendency to make horizontal photos. But remember that nature has strong vertical elements such as trees, mountains and waterfalls. If you are standing on a bridge and looking up or down a river, the

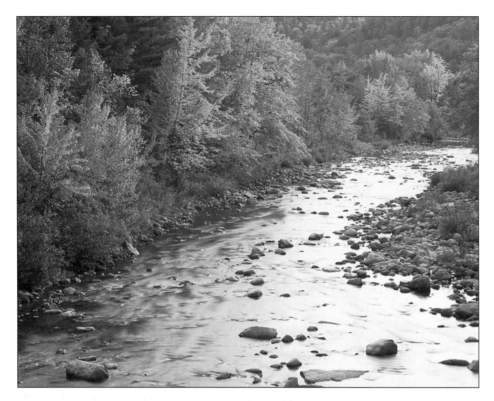

1-3 and 1-4: These two photos of an autumn scene in New Hampshire's White Mountains illustrate the choice of horizontal or vertical composition that you face in every photographic situation. Which one do you prefer? (Medium-format camera with 135mm lens)

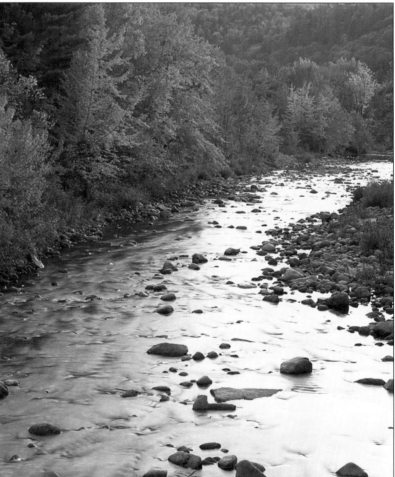

"…consider whether a vertical or a horizontal composition will be most attractive."

river will appear as a vertical element in your photograph, extending from the foreground into the distance (see photos 1-3 and 1-4). In close-up photography, even the stem of a wildflower, a vine or a blade of grass can be a strong vertical element.

In every photographic situation, consider whether a vertical or a horizontal composition will be most attractive. After looking through the viewfinder at vertical and horizontal compositions, in many cases you will feel a strong preference toward one or the other. If not, take at least one photo vertically and at least one horizontally, and evaluate your photos after they are processed. In all likelihood, you can improve your nature photography by consciously taking more verticals.

Look for Lines

Lines can be used to enhance nature photo compositions. Nature is full of lines, but how do you use these lines to enhance your photos?

Several elements to look for in your photo compositions are diagonal lines, leading lines and curving lines. Judicious placement of these lines in a photo can spell the difference between an average image and a strikingly memorable image.

1-5: The edge of the surf forms a distinct leading line that takes the viewer's eye from the lower right corner to the waterfall in this image of California's photogenic Big Sur coastline. (Medium-format camera with 135mm lens and 2X teleconverter)

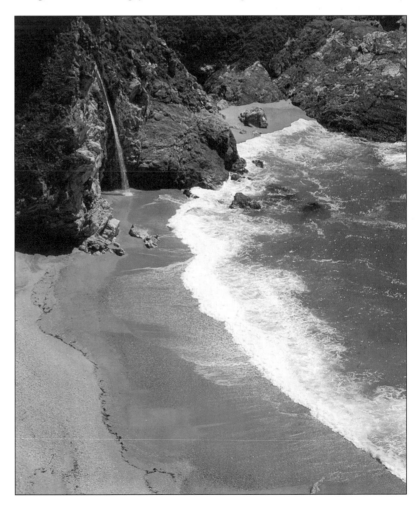

"...diagonal lines characteristically liven up photos."

Horizontal and vertical lines in photos frequently have the effect of creating boundaries within a scene, framing the scene, or creating a pattern. While horizontal and vertical lines often have a static appearance in nature photographs, diagonal lines characteristically liven up photos. While horizontal lines appear to be sleeping and vertical lines are standing still, diagonal lines are dynamic. Diagonals are often where the action is.

One particular variety of diagonal line is known as a leading line. This is a line that carries the viewer's eye and attention into the picture. A leading line may extend from at or near any of the four corners of a photo toward the middle of the image or toward a significant feature in the image. You can find many leading lines in nature such as riverbanks, borders between field and forest, fallen trees, and sloping hills and mountains. Leading lines often create a sense of depth in a photo, and they can point the way to the main subject in an image (see photo 1-5).

Curved lines are useful for adding aesthetic appeal to nature photos. In particular, S-curves frequently appear beautiful to the eye. S-curves in nature include winding rivers, meandering streams, curled tree branches, slithering snakes and lizards, swirling clouds, and the ever-changing ripples in beaches and sand dunes (see photo 1-6).

1-6: This snowy Rocky Mountain scene is enhanced by the graceful S-curve of the river. Note the choice of a vertical composition and the high placement of the horizon. (28-70mm zoom lens set at 28mm)

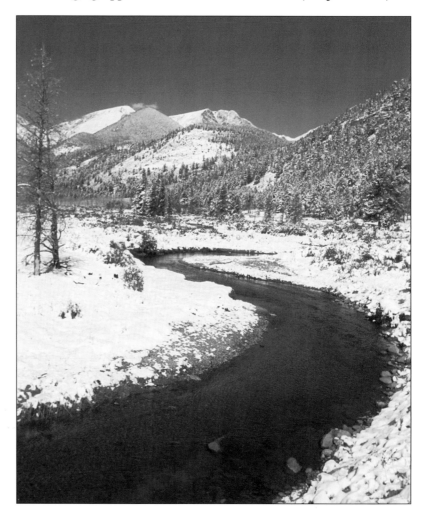

Use the Trusty Rule of Thirds

When composing photos, many people routinely put the main subject of the photo in the middle of the image. In some instances, centering the subject works well. But much of the time, this produces photos that look rather static, like portraits.

1-7: The rule of thirds suggests moving the main subject in a photo, in this case a sand dollar on a Virginia beach, away from the center of the image to produce a more interesting composition. (70-210mm zoom lens)

1-8: This Yellowstone National Park image embodies the rule of thirds. The boundary between the flowers and the talus slope is about one third of the way up from the bottom. The boundary between the talus slope and the columnar basalt is about one third of the way down from the top. (38mm lens)

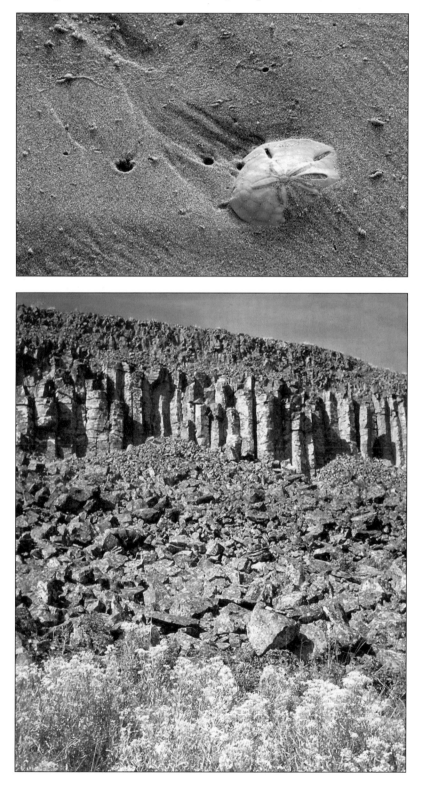

You can often produce a more interesting image by composing your photo with the main subject somewhere other than the center of the image. A simple way to keep this in mind is to use what photographers call the **rule of thirds**. To apply the rule of thirds, imagine the scene in your viewfinder is divided into thirds both horizontally and vertically. You can visualize this by pretending that a tic-tac-toe grid has been superimposed on the scene you are photographing. Now compose the image so that the main subject of the photo is located approximately at one of the intersections of these imaginary thirds lines (see photo 1-7).

For instance, if a deer is the main subject of your photo, you might compose the image so that the deer is one-third of the way up from the bottom of the image and one-third of the way across from the left side of the image.

In another case, one of the other intersections in the tic-tac-toe grid may be the best location for your main subject. You may also want to place prominent horizontal or vertical lines — such as the horizon or a large tree trunk — approximately one-third of the way from one of the four edges of the image (see photo 1-8).

The goal of using this "rule" is to produce more interesting, lively images by moving the subjects of your photos away from the center of your images and varying your photo compositions.

The Real Secret of Many Great Photos

If you truly want to produce well-composed nature photos, use a tripod. A tripod is regarded by most professional nature photographers as an absolute necessity, almost as important as having a camera, a lens and film. Why? Because carrying and using a tripod will cause you to slow down and take your time.

With a tripod, you will spend more time setting up for each photograph, and you will spend more time looking through the viewfinder to "clean up" your compositions by removing distractions and moving in as close as possible to your subject (see photo 1-9).

As a beneficial side effect, when you use a tripod and move more slowly or, better yet, stop moving altogether, your eyes as well as your other senses will open up to the natural world and you will literally see many more interesting photo subjects around you.

Nature will begin to "happen" all around you as your sensory awareness of nature blossoms. The fact that the tripod also gives you the practical advantage of being able to take long exposures — 5 seconds or even 5 hours — without shaking the camera is simply icing on the cake.

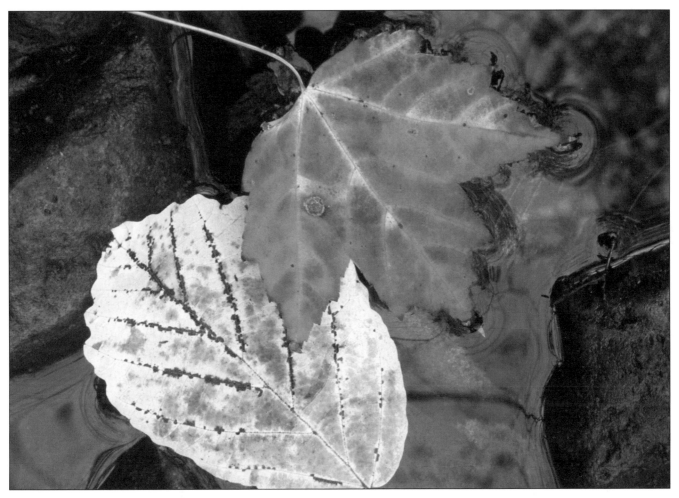

1-9: Overlapping autumn leaves in a Pennsylvania mountain stream illustrate the value of using a tripod. With your camera mounted on a tripod, you will begin to slow down to the pace of your surroundings and carefully compose your photos to produce beautiful images. (28-200mm zoom lens set at 200mm)

<div align="right">

Chapter Two

Exposure

</div>

Automatic Exposures

Today's electronically sophisticated cameras — including many point & shoot cameras — do a good job of automatically choosing the correct **exposure** in many nature photo situations. Your camera's microchip "brain" automatically selects an appropriate exposure based on (1) your film's sensitivity to light, known as the

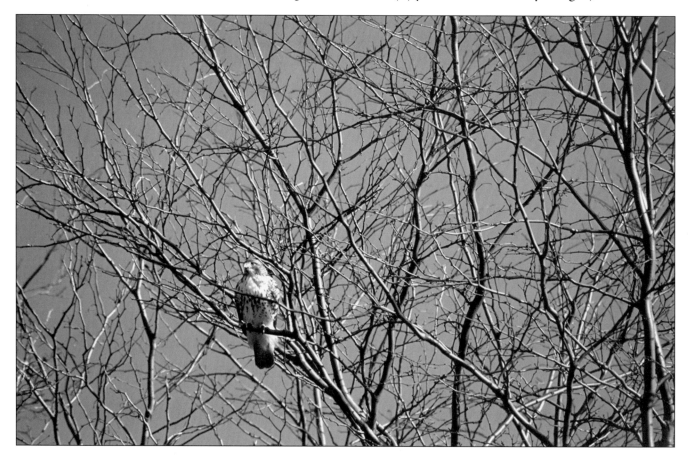

film speed, and (2) the amount of reflected light from the subject that reaches your camera. In essence, your camera chooses the proper amount of light from the outside world to expose to your film so as to produce a good photograph (see photo 2-1).

Manually Setting Exposures

Exposure is determined by the intensity and duration of light reaching your film. If you have a single-lens-reflex (**SLR**) camera that allows you to set **shutter speeds** and **apertures** (f-stops), then you can manually control exposure and creatively fine tune your photos.

Shutter Speed

Shutter speed refers to the amount of time your camera's shutter stays open — thus allowing light to reach the film — when you take a picture. Cameras use a standard series of shutter speeds measured in fractions of seconds:

1/1,000 sec.	} fast shutter speeds
1/500 sec.	
1/250 sec.	
1/125 sec.	} intermediate shutter speeds
1/60 sec.	
1/30 sec.	
1/15 sec.	
1/8 sec.	} slow shutter speeds
1/4 sec.	
1/2 sec.	} very slow shutter speeds
1 sec.	

Notice that each of these shutter speeds is twice as long as the one listed above it and one-half as long as the one listed below it. Changing the shutter speed by one "**stop**" means changing from one shutter speed to either the one listed above it or below it in this series.

Some cameras will allow you to use even faster shutter speeds than 1/1,000 sec., such as 1/2,000 sec. or even faster. SLR cameras allow you to take even slower shutter speeds than 1 sec. by setting the shutter speed to a value of multiple seconds or by setting the shutter speed to "B" and manually keeping the shutter open as long as you want by using a cable release. Many newer cameras also allow you to use shutter speeds that are between the shutter speeds listed in this series. These in-between shutter speeds are at "half-stop" intervals. For example, 1/90 sec. is a half-stop faster (shorter) than 1/60 sec. and a half-stop slower (longer) than 1/125 sec.

"Exposure is determined by the intensity and duration of light reaching your film."

2-1 (opposite page): The more you learn about exposure, the more successful you will be photographically. Your goal as a photographer is to produce exposures that look as good as the real scenes you encounter in nature, such as this image of a red-tailed hawk in New York's Hudson Valley. (75-300mm zoom lens)

Aperture

Aperture refers to the size of the lens opening through which light passes to reach your film. Camera lenses use a standard series of apertures expressed as f stops:

$f/2.8$ large aperture: lens is wide open

$f/4$

$f/5.6$

$f/8$ } intermediate apertures

$f/11$

$f/16$

$f/22$ small aperture: lens is stopped down

On your particular lenses, this series of f-stops may not extend as far or the series may extend further in either direction, for example, to $f/2$ or $f/32$. Apertures are written in this way because each aperture is defined as the **focal length** (f) of the lens divided by a particular number.

The focal length is the distance from the optical center of a lens to the film, measured in millimeters. For example, when a lens with a focal length of 100mm is set at $f/4$, the diameter of the lens opening is 100mm/4 = 25mm. Don't worry, you don't need to remember this to take good photos!

This series of apertures is set up so that each aperture allows in twice as much light as the one below it and one-half as much light as the one listed above it. Changing the aperture by one "stop" means changing from one aperture to either the one listed above it or below it. Your lenses may allow you to also set apertures at half-stop intervals between the apertures listed on this series, for example, at $f/19$, halfway between $f/16$ and $f/22$.

Since changes in aperture and changes in shutter speed are both measured in stops, in a particular photographic situation you have the choice of several different combinations of aperture and shutter speed to expose your film to the correct amount of light.

For example, if your camera's exposure meter shows you that $f/11$ at 1/250 sec. is a correct exposure, then $f/8$ at 1/500 sec., and $f/16$ at 1/125 sec. would also allow the same amount of light to reach the film. To choose which combination will work best in a given photo situation, consider the following information.

How to Choose Shutter Speeds

Your choice of shutter speed is critical when your photo subject is moving. If you use slow shutter speeds — 1/30 sec. or 1/15 sec., for example — to photograph moving animals or flowers blowing in the breeze, your photo subjects will be blurred. A fast shutter speed, 1/500 sec. or 1/1000 sec, for instance, will nearly

Quick Tips

Both apertures and shutter speeds are measured in stops. This gives a choice of different combinations you can use when taking a photo.

2-2: In this image of mallards on a Pennsylvania lake at sunrise, a shutter speed of 1/125 sec. was fast enough to freeze the motion. Had the birds been moving more rapidly, or had they been closer, a faster shutter speed would have been necessary. (28-200mm zoom lens)

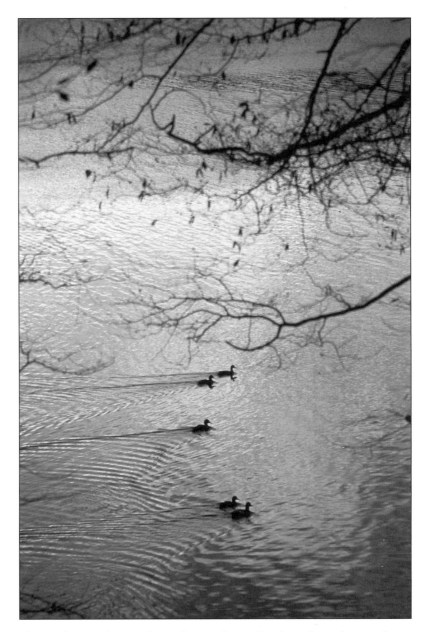

always freeze the motion of a moving animal, and produce a sharp image. When an animal is moving slowly or it is far enough away to appear quite small in the image, a shutter speed of 1/125 sec. or 1/250 sec. is often adequate (see photo 2-2).

The best way to learn what shutter speed is necessary to freeze motion in a particular situation is to learn from your own experience. When you are photographing running water in rivers and streams, you may produce a variety of different creative effects depending on your choice of shutter speed (see photos 2-3 and 2-4).

Also, if you are not using a tripod, you will often get blurred images when you use slow shutter speeds because of "camera shake." The problem is that most people cannot hold the camera perfectly still for more than a small fraction of a second. Many photographers use the guideline that when you are hand-holding the camera, you

2-3 and 2-4: These two very different images of a swift Rocky Mountain stream are the result of different shutter speeds. The top photo was taken at 1/125 sec. at f/4. The bottom photo was taken at 1/4 sec. at f/22. In other words, the second exposure was more than 30 times as long as the first. (17mm lens)

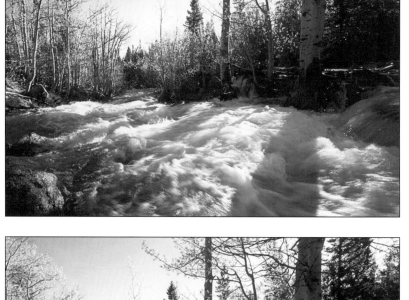

should not use a shutter speed slower than the reciprocal of the focal length of your lens. For example, if you are using a 35-70 mm zoom lens set at 60 mm, you should try to avoid using shutter speeds longer than 1/60 second. So 1/125 sec. or 1/250 sec. would be okay, but 1/30 sec. or 1/15 sec. would not be. Through experience you can find out what works for you.

How to Choose Apertures

If your photographic subject is not moving and you have mounted your camera on a tripod, then your choice of aperture should be your first priority. Your choice of aperture is important because it helps determine the **depth of field** in your photos. Depth of field refers to the range of distances, from near to far, that appear sharply focused in a photo. This zone of sharpness extends from some distance in front of the point on which your lens is focused to some distance behind the point on which your lens is focused. The smaller your lens aperture, the greater your depth of

Quick Tips
Aperture helps determine the depth of field. Depth of field simply refers to the range of distances that appear sharply focused in a photo.

*2-5 **and** 2-6: The appearance of photos depends on your choice of aperture, because lens aperture influences depth of field. The top photo of wildflowers in the Great Smokies was taken at 1/60 sec. at f/8. The bottom photo — with much greater depth of field — was taken at 1/8 sec. at f/22. (75-300mm zoom lens set at 230mm)*

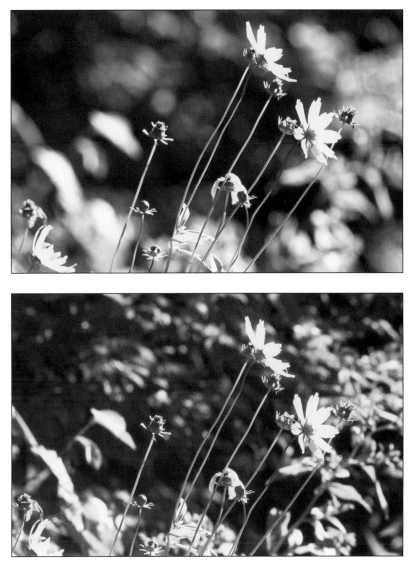

field. Thus, if you set your lens at $f/16$, $f/22$ or $f/32$ — small apertures — you will have much more depth of field than at $f/2.8$, $f/4$ or $f/5.6$ — large apertures (see photos 2-5 and 2-6).

When you are setting your aperture, you may find it useful to think of yourself as "dialing in" the preferred amount of depth of field — apertures such as $f/2.8$ and $f/4$ give less depth of field, $f/16$ and $f/22$ give more.

Please note that depth of field also depends on the focal length of the lens — the longer the focal length, the less depth of field — and on the distance the lens is focused at — the greater the focusing distance, the greater the depth of field.

There are three ways to determine how much depth of field you have in a given situation:

1. A **depth-of-field preview** feature built into some SLRs lets you see the actual depth of field through your viewfinder. See Chapter Seven for more information on this feature.

2. Some lenses have a depth-of-field scale marked on the top of the lens to show your depth of field at various apertures and focusing distances. See your lens owner's manuals for information about this feature.

3. Depth-of-field tables are available in photographic reference books and are also sometimes distributed with new lenses.

Easy Exposure Situations

When you camera's built-in **exposure meter** chooses how to expose a particular photo, it is measuring or "reading" the amount of light reflected toward the camera from various parts of the scene you are trying to photograph. Exposure meters are calibrated to choose an exposure that will reproduce an overall medium-gray tone in the image; this medium gray is a middle tone in between white and black.

In essence, no matter what colors or levels of brightness are present in the scene you are photographing, your camera sees the world through medium-gray tinted glasses. So your meter works fine when the scene you are photographing is largely made up of middle tones. This is true in many outdoor scenes, for example, if the image you see through the viewfinder is dominated by well-lit green leaves, green grass or gray tree bark. Fortunately, many such nature scenes are a proverbial piece of cake for your camera's exposure meter, and your camera automatically chooses a suitable exposure to produce an excellent photo.

Making the Best of Difficult Exposure Situations

One of the major challenges of nature photography is that you sometimes encounter tricky exposure situations in the field where your camera's exposure meter may not automatically choose an optimal exposure. This results in either overexposure or underexposure. When the film is exposed to too much light, the photo comes out too light — colors appear less saturated than in the original scene and the image may appear "washed out." This is referred to as an **overexposure**. When the film is not exposed to enough light, the photo comes out too dark and is an **underexposure**. Some difficult nature photo exposure situations are extremely light subjects, extremely dark subjects, and extremely contrasty subjects such as a very dark subject against a light background. The subsequent chapters on techniques for photographing wildlife, landscapes and close-ups give examples that illustrate solutions for dealing with difficult or tricky exposure situations.

One of the most common exposure challenges in nature photography is a scene dominated by shades that are considerably lighter than a medium-gray tone; for example, a white sand beach at midday, or light-colored flowers in direct sunlight, or a snowy landscape in direct sunlight (see photo 2-7).

Quick Tips

Exposure meters select an exposure that will reproduce an overall medium-gray tone in the image.

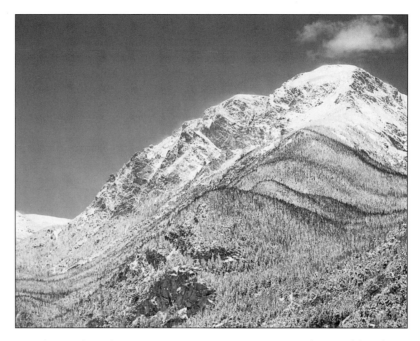

2-7: A sunlit, snow-covered Rocky Mountain landscape has an average tone much brighter than a medium gray. To make the snow white, not gray, the photo was purposely overexposed by one stop compared to the exposure meter reading. (Medium-format camera with 300mm lens)

Remember that your exposure meter expects the world to be a medium-gray or middle tone on average and selects exposures to reproduce middle-toned photos. But when photographing sunlit snow, sand or water or an image filled with light-colored flowers, the average tone of the scene is far lighter than a medium gray. Consequently, photographs of white or very bright subjects often come out grayish, not white, because they are underexposed compared to the actual scene.

In these situations, think of the phrase, "add light to light." In simple terms, when you encounter scenes that are much lighter than medium-gray, purposely overexpose ("add light") compared to your exposure meter reading. If your camera has manual exposure control, then overexpose between 1/2 and 2 stops compared to your exposure meter reading by opening up the aperture or using a slower shutter speed (see photo 2-8).

2-8: This dogwood blossom scene was far lighter than a medium-gray tone, so using the exposure meter reading would have produced an image much darker than the actual scene. Instead, the camera was set to overexpose the image by two stops to produce truer-to-life tones. (70-210mm zoom lens set at 210mm)

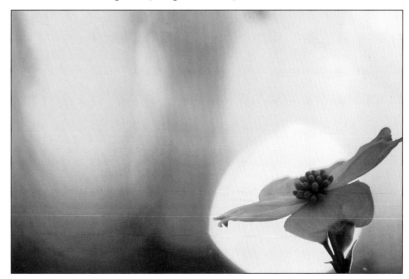

"…you can learn a great deal by taking two or three exposures of the same scene."

Experiment with your camera, write down the exposure settings you use, then review your photos to determine what works best for you. In difficult exposure situations in general, you can learn a great deal by taking two or three exposures of the same scene with slightly different exposure settings, then comparing the results. This technique of taking an exposure at the metered exposure setting then additional exposures at other settings varying from one another by half or full stops is called **bracketing** exposures.

If you are using a point & shoot camera, then you may use the camera's **backlight compensation** feature when photographing sunlit snow or water or other very light scenes. This common feature on point & shoot cameras purposely overexposes the scene compared to the exposure meter reading to produce lighter photos, more similar to the real scene. Or you may find that given your choices of camera and film, it works best to avoid photographing extremely bright scenes in direct sunlight.

Most SLRs today, and a growing number of point & shoot cameras, give you the option of using a built-in **spot meter**. This is an exposure meter that only evaluates a small "spot" in the center of the image you have composed in your viewfinder. In difficult exposure situations, one strategy to get a correct exposure is to use your camera's spot meter to read the light off of the most important subject in your photo.

As a general rule, if you are using color print film, lean toward metering off darker parts of the image; if you are using color slide film, lean toward metering off lighter parts of the image.

CHAPTER THREE

Focusing

Autofocusing

Focusing is usually taken for granted to such a degree that many how-to books about nature photography barely mention focusing. Accurate focusing, however, is essential to good nature photography (see photo 3-1).

3-1: Whether done automatically or manually, accurate focusing is critical to successful nature photos. This Virginia wetlands scene is powerful because the sharply focused cattails and other marsh plants are silhouetted against a simple background. (70-210mm zoom lens)

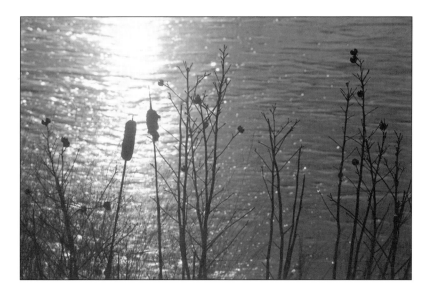

Even if you rely completely on autofocusing, you can produce much better nature photos by learning to make the best use of your camera's **autofocus** capabilities. Rapid, precise autofocus systems, which came into widespread use in the late 1980s, represent a great advance in photo technology. If you have a modern point & shoot camera, then you are totally reliant on your camera's autofocus system; that is, you do not have the option of manually focusing. Autofocus SLRs usually give you the option of choosing to autofocus or manually focus depending on the photographic situation.

It is extremely important for you to learn from your camera owner's manual what your camera autofocuses on. Most cameras autofocus on a point at the center of the viewfinder; this autofocusing position is denoted by a set of brackets ([]), a small rectangle or a cross at the center of the viewfinder.

In some cases, the camera autofocuses on several such points (for example, three rectangles arranged in a row across the center of the viewfinder). Your camera may even give you control over which of several autofocusing points to use in a given situation.

Autofocus cameras, both point & shoots and SLRs, actually focus when you push the shutter release halfway down. Many autofocus cameras confirm that the camera has focused by giving you a focus-confirmation signal; often this is a steady green light visible in the viewfinder.

This is quite important. If you focus, but do not receive your focus-confirmation signal, you are probably trying to get your camera to do something it cannot do.

For example, if you try to autofocus on a flower two inches from your lens, you are probably far too close to focus. If you took a picture in such a position, it would in all likelihood be badly blurred. Assuming your camera autofocuses on a single central point, make sure that you put the main subject of your photo — or another object at approximately the same distance from you as the subject — at the center of the image so that your camera will be focused on your subject.

Pre-Focusing

The statement above may give the impression that you must always center your subject in the photo when you are using an autofocus camera. If so, that would indeed be unfortunate, because — as you have already learned — great nature photos are often best composed with the main subject off-center in the image.

Fortunately, even inexpensive point & shoot cameras are often equipped with pre-focusing, or **focus lock**, capability. On point & shoot cameras and autofocus SLRs with this feature, when you push the shutter release down approximately halfway (not so far down as to take a picture), the camera autofocuses and remains focused until you take your finger off the shutter release.

Check your camera owner's manual to determine if your camera has a focus-lock feature. If so, you can (1) center your subject in your viewfinder, a deer for example, (2) push the shutter release down halfway and check for your focus-confirmation light, then (3) while still holding the shutter halfway down, recompose your photograph for the best composition, and (4) take the photo.

Once you get used to working the focus lock, it is very easy. This technique will help to improve the majority of your photos by allowing you to focus precisely on the main subject while creating interesting compositions with the subject off-center in the photo (see photo 3-2).

Quick Tips

To pre-focus, center the subject in your viewfinder, push the shutter release halfway, recompose your photo, then take the photo.

3-2: When using autofocus, pre-focusing is essential in a composition with an off-center subject. Center the subject — in this example, the geese — and depress the shutter release halfway to activate the autofocus. Continue to hold the shutter release down while recomposing, before taking the picture. (70-210mm zoom lens)

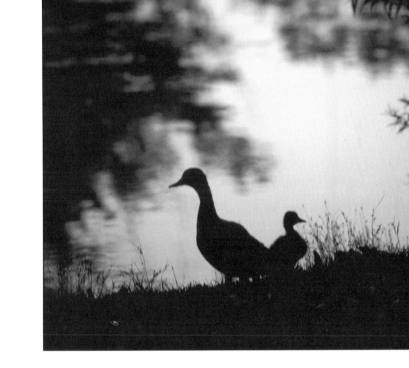

"The infinity lock will tell your camera to correctly focus at infinity…"

Infinity Lock

Many cameras have an infinity-lock feature. When you activate this feature, by either pushing an infinity-lock button or by selecting your camera's "infinity mode" (sometimes symbolized by mountains), your camera will autofocus at infinity; that is, far, far away. The reason for this feature is to ensure that the camera will focus at infinity when it might not otherwise do so.

An autofocus system is sometimes "confused" and does not know where to focus when it does not "see" any detail (lines, textures, shapes, patterns) in the center of the image. This may happen for instance when you photograph a relatively featureless sky (see photo 3-3).

Or if you photograph through a window, your camera may mistakenly autofocus on the window rather than on the scene outside. The infinity lock will tell your camera to correctly focus at infinity in these sorts of situations.

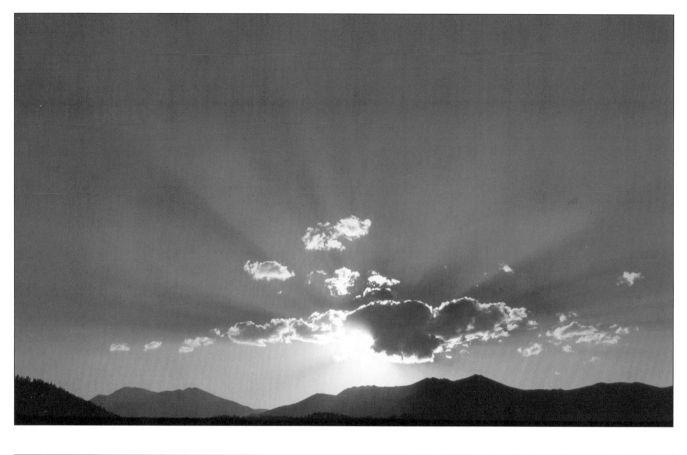

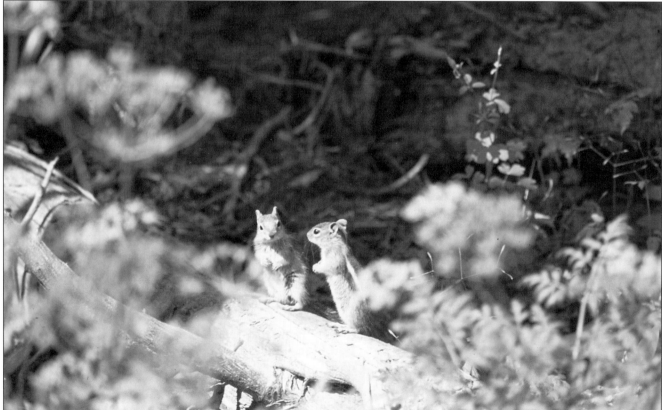

3-3 (opposite page, top): When using an autofocus camera to take sky-dominated image such as this Rocky Mountain sunset, activate the camera's infinity-lock feature. This ensures the camera will correctly focus at infinity. (70-210mm zoom lens)

3-4 (opposite page, bottom): When manually focusing, be sure to get the most important elements in the photograph in focus. In this case, the eyes of these ground squirrels in Utah must be sharply focused; everything else in the photo is secondary in importance. (75-300mm zoom lens)

Manually Focusing

If you have a relatively recent 35mm SLR camera, then you probably have the option of either autofocusing or manually focusing. If you have an older (pre-1985) 35mm SLR, then you must manually focus. When manually focusing, always ask yourself what is the most important point in the photograph to get absolutely sharp. Then take your time and carefully focus (see photo 3-4).

If you are manually focusing with a zoom lens, keep in mind that you can usually focus much more accurately by setting the lens to its longest focal length. Once you have composed your photo, zoom to your longest focal length (for example, 70mm on a 35-70mm zoom lens) and focus on the main subject, then zoom back to the focal length you want to take the picture at, recompose, and take the photo.

Also, if you are manually focusing with an autofocus SLR, you can use your camera's autofocus capability as an electronic rangefinder to double-check your focusing. Even when set on the manual focusing mode, many autofocus SLRs still illuminate a focus-confirmation light when the lens is correctly focused. This is especially useful if you are using long telephoto lenses to photograph wildlife in low light, and it is difficult to see your subject well or focus precisely.

Further specific tips about focusing are given in the subsequent chapters on techniques for photographing wildlife, landscapes and close-ups.

PART TWO
Nature Photo Techniques

CHAPTER FOUR

Photographing Wildlife

Getting to Know Wildlife

One of the most important determinants of successful wildlife photography is knowledge of the animals you want to photograph. Find out everything you can about your wildlife photo subjects. Knowing the answers to these questions will help you find and successfully photograph various species of animals:

Where do they live?

What do they eat and what eats them?

What habitats do they prefer for feeding and cover?

What are their daily, nightly and seasonal patterns of activity?

What kind of tracks, scat or other signs do they leave behind (see photo on opposite page)?

How acute are their senses of sight, hearing and smell?

What are their patterns of social organization, how do they communicate, and what do their sounds and other behaviors mean?

When and where do they reproduce?

To what degree will they tolerate human intrusions, and is your presence potentially harmful to them?

Are they potentially harmful to you?

The last question may seem like a trivial point. After all, doesn't every outdoor enthusiast know which animals are potentially dangerous? Hardly! Many folks try to avoid contact with snakes,

Opposite page: Learning to identify the signs of wildlife, such as these white-tailed deer tracks in snow in the Appalachian Mountains, is an extremely useful skill to help you find and photograph animals. (28-70mm zoom lens)

insects, and spiders, the vast majority of which are harmless, and often even beneficial to people. Meanwhile, hundreds of camera-wielding visitors to the major national parks put themselves in harm's way every summer day by getting much too close to bears, bison, bighorn sheep and elk. The negative consequences of too-close encounters between people and large mammals are usually avoidable. The moral: know your wildlife.

There are many good sources of information about wildlife. In addition to dozens of wildlife field identification guidebooks — the *Peterson* and *National Audubon Society* field guide series are among the best — local nature centers, wildlife advocacy organizations, and regional offices of state and federal natural resource agencies can help you learn about the wildlife of your area.

4-1: Observing wildlife is in itself an enjoyable and rewarding activity. Getting good photos makes it even more fun. Photogenic wildlife species, such as the great blue heron, are readily observable wherever suitable habitat exists, even in many urban and suburban areas. (75-300mm zoom lens)

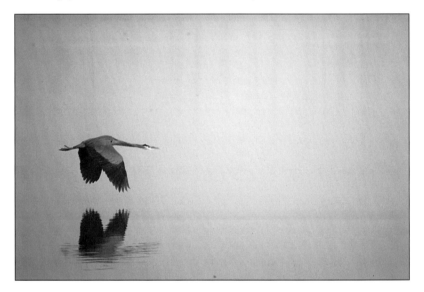

For learning about wildlife, there is no substitute for time you spend directly observing animals in the wild (see photo 4-1). Watching the animals you want to photograph is not only pleasurable, superb therapy, and a great activity to share with friends and family, it is also the best way to learn about the behavior of your photo subjects. Professional nature photographers spend literally hundreds of hours, sometimes even hundreds of days, closely observing the animals they photograph. A single magazine cover photo often is the product of months of field photography.

Where to Photograph Wildlife

To some people, wildlife photography means going on a safari to an exotic African destination. If you have such an opportunity, that's great. But there is no better location than the place you live to develop your wildlife photo skills and produce some excellent photos in the process.

In terms of learning nature photography, Dorothy was right in *The Wizard of Oz* — there's no place like home. The photo skills you develop in your backyard or your local parks and nature pre-

"A single magazine cover photo often is the product of months of field photography."

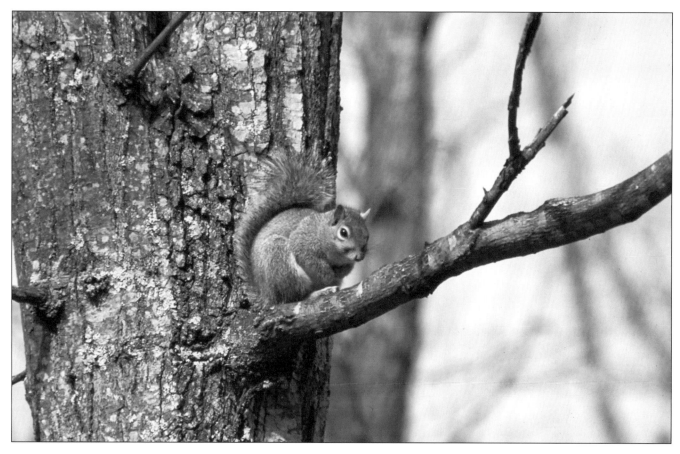

4-2: To become a good wildlife photographer, the best place to start is your own backyard. Readily accessible local birds and mammals, like this gray squirrel, give you an opportunity to develop your photo skills. (exposure: 1/90 sec. at f/8 with 180mm lens and 2X teleconverter)

serves are easily transferable to wildlife-rich national parks, wildlife refuges and wilderness areas.

If you can consistently make good photos of squirrels and songbirds in neighborhood trees, you will have much a much greater chance of success, and much greater confidence, on your summer holiday when you have an opportunity to photograph the deer and the antelope playing (see photo 4-2).

When to Photograph Wildlife

More outstanding wildlife photographs are taken within a few hours of sunrise and sunset than at any other time of day. This is because so many animals are active and visible at either end of the day. In addition, on sunlit days, the warm light and long shadows of early morning and late afternoon are conducive to interesting photographs.

Conversely, the middle of the day — especially in summer — usually offers less interesting lighting and much less wildlife activity. For a wildlife photographer, mid-day is an excellent time to catch up on the sleep you missed by getting out early to catch the first light of the day (see photo 4-3).

When to photograph a particular animal largely depends on its specific set of behaviors. Action shots of largely nocturnal animals such as flying squirrels, owls, and opossums are unusual at mid-day. Many birds are quite active at dawn and dusk. These are also ideal

4-3: This red-winged blackbird, silhouetted against the early morning sky in a Virginia marsh, is indicative of the wildlife photo opportunities available to early risers. Go out in the field early and stay out late. (70-210mm zoom lens)

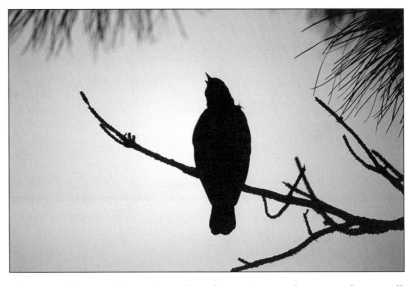

times to observe elk grazing, deer browsing, and many other small creatures feeding.

Patience Means Everything

Take your time. Nature is not a vending machine, an Internet site, or a theme park — you cannot download it or make it "happen" on command. Nature always moves at its own pace. Good wildlife photography takes great patience. Photographing everywhere from the Arctic to the tropics, from frozen fjords to rice paddies, I have observed that finding and photographing the truly extraordinary scenes in nature just takes a lot of time. That is one of the reasons nature photography is so demanding and so rewarding. Opportunities to photograph the magical light of a memorable dawn, a perfect dew-covered wildflower meadow, or migrating geese streaking across the face of the full moon are available to the photographer who is in the right place at the right time. You simply have to be there (see photo 4-4).

4-4: Photographing uncommon wildlife, such as the threatened spotted owl of the Northwest's old-growth forests, requires patience and perseverance. Knowledge of the animal's habitat and behavior greatly increases your chances for photographic success. (28-200mm zoom lens set at 200mm)

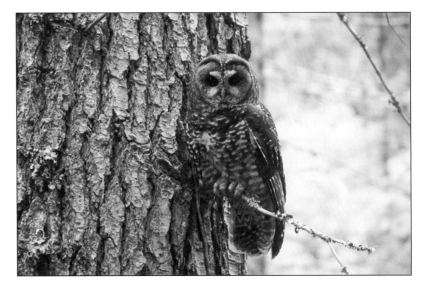

Baiting Wildlife?

No, no, no! With the sole exception of a permanent, well-maintained backyard bird feeder, feeding wildlife for the sake of attracting animals to photograph is a bad idea. Feeding of wild animals, particularly in residential and park areas, has numerous detrimental consequences:

1. The animals may develop an increased dependence on humans for food, along with a markedly decreased ability to survive in the wild.

2. Animals that are routinely fed may become malnourished. This is frequently the case with ducks and geese that learn to subsist on human handouts in municipal park ponds, rather than on a varied and far more nutritious natural diet. Keep in mind that waterfowl, squirrels and raccoons did not evolve over millions of years while eating junk food.

3. Wild animals that learn to get food from humans may exhibit aggressive behavior towards people and pets with unfortunate results for all concerned. "Panhandling" animals that frequent backyards and parks can also carry serious diseases such as rabies.

Remember that wild animals are by definition not domesticated animals. Rely on your knowledge of animals and your patience — not on a bag of potato chips or a loaf of moldy bread — to get those great wildlife photos.

Using Long Lenses

In general, wildlife photography is the branch of nature photography in which you will most often use the longest lenses you have. If for example you are using a point & shoot camera with a 38-115mm **zoom lens**, you will frequently find yourself using your longest focal length, 115mm, to photograph animals. If you have an SLR with a 70-210mm zoom lens, you will likely use the 210mm setting for much of your wildlife photography (see photo 4-5). To produce wildlife portraits, a point-and-shoot camera that zooms to more than 100mm or an SLR with a zoom lens that extends to at least 200mm is a good idea. If you are truly passionate about wildlife photography, either a 70-300mm zoom lens or a 400mm lens is an ideal acquisition.

Keep in mind that depth of field — the front-to-back zone of sharpness in a photo — is dependent on the focal length of your lens. As previously stated, the longer the focal length of the lens, the smaller the depth of field. The upshot of this is that precise focusing is critical when using long **telephoto lenses** to photograph animals. Because you are greatly magnifying your wildlife photo subjects when you use a long telephoto lens, any movement of the lens is also magnified, and can result in consistently blurred photos. In

Quick Tips
Two good lenses for wildlife photography are a 70-300mm zoom lens and a 400mm lens.

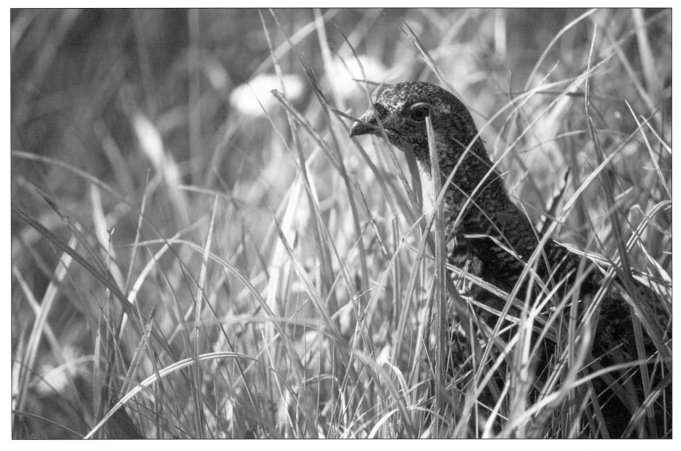

4-5: A good telephoto lens and plenty of patience add up to successful wildlife portraits. Note the low perspective used to photograph this grouse in Olympic National Park. By staying close to the ground, you will be much less likely to disturb your photo subjects. (70-210mm zoom lens set at 210mm)

addition, longer lenses are heavier and often difficult to hold steadily. Thus, if you use lenses of 300mm or longer, by all means use a tripod whenever possible to ensure your camera and lens remain still while you are shooting.

Favorite Wildlife Photo Subjects

Everyone has favorite animal photo subjects, whether they are backyard squirrels, the elk in Yellowstone National Park, or the waterfowl at a nearby wetlands area. Specific wildlife photo subjects require specialized techniques as described in the following sections.

Large Mammals

Judging by how frequently various types of wildlife appear on the covers of magazines and coffee-table photo books, large mammals such as deer, caribou, elk, bears, bison, cougars, antelope, wild sheep and goats, and marine mammals are among the most popular of wildlife photo subjects.

An inherent advantage of photographing large mammals is that the animals are big enough that you do not have to be exceptionally close to photograph them and you do not necessarily need a long telephoto lens to get a good photo. In fact, herds of elk, deer and antelope are so accessible in many national parks and other public lands that you can do very well photographing them with a point & shoot camera.

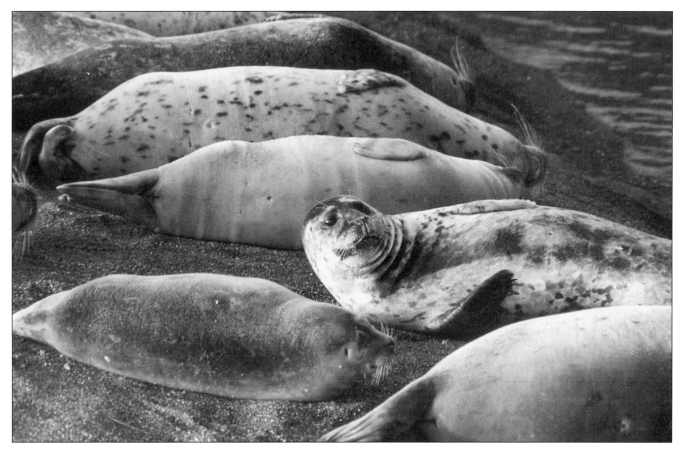

4-6: A single well-lit eye in sharp focus makes this California harbor seal photo a success. The visible graininess of the photo, characteristic of the ISO 200 slide film used for this exposure, enhances the texture of the mottled seal fur and the coarse sand beach. (180mm lens)

"Strive for candid, spontaneous wildlife photos..."

One feature that is essential for a good photo of a large mammal is to make sure that at least one of the animal's eyes is readily visible and in sharp focus. Why? Because when we see an animal or an animal photo, we immediately look to the eyes, just as we make eye contact with other people. Looking at the eyes is part of the way we instantly try to identify an animal. So attempt to always get a clear, unobstructed view of at least one of the animal's eyes; watch out for obstructions such as tree branches or even tall grasses. A well-lit eye is preferable to one in deep shade. Whether you are autofocusing or manually focusing, make sure that the eye is sharply focused (see photo 4-6).

If you are using a point & shoot camera, this is an ideal situation to use the pre-focusing technique that was previously discussed; focus on the eye of a stationary animal, activate the focus lock by partially depressing the shutter release, then recompose for the best composition and take the photo.

When photographing large mammals, try to go beyond the cliche of animal portraits that appear to be to be posed, with a wary-looking animal standing stiffly at attention. Strive for candid, spontaneous wildlife photos in which the animals are not reacting to the photographer or to other people, but instead are exhibiting their normal behavior (see photo 4-7). The more time you observe large mammals, the better your photos will be. If the animals you want to photograph are aware of your presence, then be still and

39

4-7: This white-tailed deer moving through a snowy forest in Shenandoah National Park makes a more interesting photo than the typical portrait of deer standing frozen at attention. Try to photograph animals that are not reacting to you. (250mm lens)

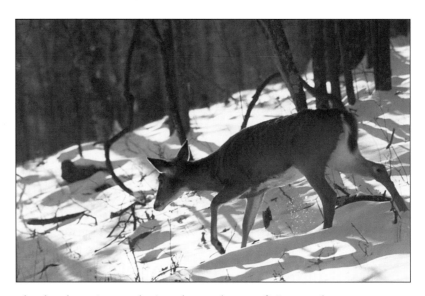

absolutely quiet, and give them plenty of time to become accustomed to you. In many cases they will ascertain that you are not a threat to them, and they will resume their everyday behavior. Look for interesting interactions between individuals, such as play or mutual grooming, or even interactions between different species.

Small Mammals

Though maybe not as powerful looking as a photo of a huge bull elk bugling in the wilderness, photos of small, furry creatures are a favorite of many nature photographers. For one thing, small mammals — including backyard squirrels, rabbits, raccoons, groundhogs, opossums and chipmunks — are often present in larger numbers in residential areas and local parks.

Despite their small size, and their necessary wariness of predators, many of them are surprisingly approachable and even gregarious around nature photographers. Keep in mind that these animals are indeed small, and may often appear even smaller than you anticipate in your photos. To assure getting good small mammal photos, either you need to use at least a moderate-length telephoto lens, 135mm or longer, or you need to be quite close to the animals (see photo 4-8).

One of the pronounced traits of small mammals is that their survival dictates that they move quickly. If they feel threatened by your approach, they will immediately either run to dense cover, go to a nearby burrow or climb a tree far out of reach. Thus it is important to learn each animal's "safety distance", in other words, how close you can be to the animal before it will react by moving to safety. As a nature photographer, you will get many of your best photos by operating just outside that zone. As previously stated, knowledge of your animal photo subjects and patience are key ingredients of good wildlife photography. To freeze the rapid motion of small mammals, you will often need to use shutter speeds of 1/125 sec. or faster, depending on how fast the animal is moving, what lens you

Quick Tips
To freeze the rapid movements of small mammals, use shutter speeds of 1/125 sec. or faster.

4-8: A ground-level perspective, just above the grass, makes this curious, bright-eyed marmot in Colorado appear larger. The "catch light" in the marmot's eye is provided by the point & shoot camera's fill-in flash. (80mm lens, taken from close range)

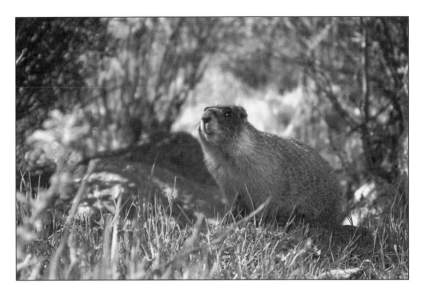

are using, and how close you are to the animal. If you are using a point & shoot camera, you cannot manually set shutter speeds, but you can use medium-to-high-speed film (ISO 200 or ISO 400) so that your camera will automatically select faster shutter speeds.

Waterfowl

Geese and ducks are accessible photo subjects, at least seasonally in most regions. The comparatively large size of waterfowl, their large populations, their social behavior, and their tolerance — in some cases — of human presence are factors that favor them as photo subjects (see photo 4-9).

When photographing waterfowl, nature photographers often use blinds to conceal their presence and thus get closer to the birds. A **blind** is a temporary or permanent camouflaged structure large enough for one or several photographers. A variety of blinds can be purchased or you can build a simple blind out of downed tree branches and other natural materials or out of fabric with tent poles

4-9: A pair of mallards floating on a Virginia pond after sunset makes a nice silhouette. If you closely observe the daily movements of waterfowl, you can frequently get good photos by moving into a secluded position and allowing the birds to come to you. (70-210mm zoom lens)

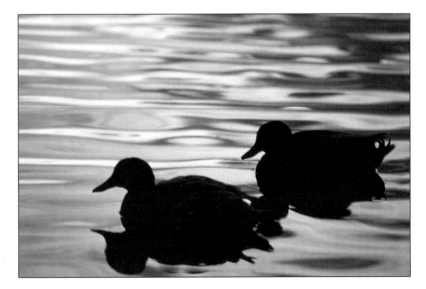

as supports. Wildlife refuges sometimes have permanent blinds set up for observation. Before setting up a blind, observe animal activity in an area to determine a good site, and make sure that you have proper permission from public land managers or private landowners to put up the blind. In many wildlife refuges, you can park near wetlands and use your car itself as a blind; some animals are far less wary of a car or a truck than of a person on foot.

As you learn to photograph waterfowl, you might start off by photographing slow-moving birds floating on the water. With patience and practice, you can get great pictures of waterfowl in their explosive take-offs from the water. Also, practice following the birds in flight through your camera's viewfinder. When taking flight photos, vary your shutter speeds, using high-speed film and fast shutter speeds (1/500 sec. and faster) to freeze the rapid motion of the wings. Or use slow film and slower shutter speeds for creative blurring of the birds' motion.

Look for interesting interactions between birds, learn to anticipate the timing and direction of take-offs and landings, and seek out-of-the-ordinary photo opportunities such as geese sliding on ice.

Birds of Prey

Almost everyone enjoys the sight of an eagle, hawk, falcon or owl. The wildness, grace and sheer power of these hunters of the sky make them a favorite photo subject. Opportunities to photograph some of the most photogenic birds of prey — bald eagles, ospreys and peregrine falcons — are greatly expanding as these species continue their surprising population recoveries after nearly disappearing from many regions a quarter-century ago due to long-lived toxic pesticides and habitat loss (see photo 4-10).

Fortunately for nature photographers, many birds of prey spend much of their time sitting almost motionless, carefully surveying their surroundings. For good photos of raptors, get as close as you can without disturbing the bird. How close? This depends on the

"...practice following the birds in flight through your camera's viewfinder."

4-10: The majestic bald eagle is now a more common sight in American skies than it has been for decades, much to the joy of nature photographers. Notice how the bare tree branches provide a sense of scale in this simple composition of an eagle soaring in Oregon. (75-300mm zoom lens set at 300mm)

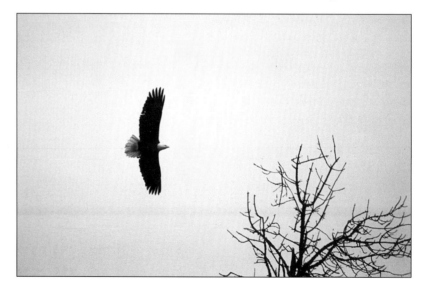

species, the time of year, the habitat and the individual bird's previous experience with people. The distance may vary from fifty feet to several hundred feet or more.

Please keep in mind that birds of prey are protected under federal law and that many birds of prey such as the bald eagle are easily disturbed by human intrusion. Keep your distance from raptor nests to avoid any interference in the birds' ability to successfully reproduce and maintain their populations.

Birds of prey have very regular patterns of hunting or fishing behavior. For example, kestrels hover like feathered helicopters for minutes at a time over grassy areas as they hunt small rodents, and ospreys circle around and around over open water before diving for fish. Once you learn these patterns, you can position yourself to capture the interaction between raptors and their prey. An interesting technique that takes some practice is to follow a fast-flying hawk or falcon through your viewfinder. While panning to keep the bird in the same position in your viewfinder, use a shutter speed of approximately 1/60 sec. or 1/125 sec. to produce a striking photo of a sharply focused raptor against a background that is purposely blurred by your camera movement.

Backyard Birds

Virtually anywhere people live — from the tropics to the high latitudes, from arid to moist climates, from rural areas to the largest cities — backyard birds can be found. To improve your photo opportunities, you can create a better habitat for backyard birds. Techniques range from simply providing a bird feeder on an apartment terrace, to putting up nesting boxes for favorite species in your yard, or actually landscaping your property with plantings that provide food and cover for backyard birds.

If you are patient, many songbirds can become quite accustomed to your presence and will allow you to photograph from close range. When you photograph songbirds, you begin to appreciate how small they really are, so use the longest lens you have and get as close as possible. Consider using medium-to-high-speed films, ISO 200 or ISO 400, to freeze the rapid motion of small birds.

Many good backyard bird photos, especially snowy winter portraits, are taken from indoors. With a little practice, you can take excellent bird photos through a window, and you can enjoy a nice, warm cup of coffee while you watch the birds in the swirling snow (see photo 4-11).

Make sure the window is very clean on both sides, line up the camera so that the front of the lens parallels the plane of the window, and turn off inside lights to reduce reflections in the window. Do not use a flash when shooting through a window; the light from a flash would be reflected in the window and would dominate the photo.

Nature photographers often leave a camera set up on a tripod in a room with a good view of a backyard bird feeding station. This

Quick Tips

Birds of prey are creatures of habit. Learn their regular patterns, then position yourself to capture stunning images of these birds hunting their prey.

4-11: This pileated woodpecker was photographed through a living room window during a snow shower in Virginia. To maximize chances of success in such situations, turn out interior lights to prevent reflections. (exposure: 1/250 sec. at f/4 with 250mm lens)

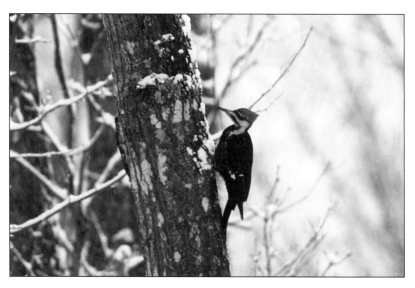

increases the chances you will be ready when the perfect bird photo opportunity happens, and it also helps the birds get used to the presence of the camera equipment.

Itty-Bitty Creatures

Nature's smaller animals are also among the most photogenic. Of course, size is relative — to an aphid, a grasshopper would appear gigantic. In any case, there are a host of small creatures that are excellent photo subjects; for instance, frogs, lizards, salamanders, butterflies, moths, beetles, spiders, ants, bees, caterpillars, and slugs (yes, slugs).

Many little creatures have brilliant coloration, striking patterns, or intricate camouflage. Unlike many large animals, these small wonders are very accessible in local parks and backyards.

The same keys to success apply to photographing these animals as apply to photographing all wildlife: get to know them and be patient. The biggest key to successful photography of very small

4-12: Photographing very small animals requires getting quite close to them. Take every opportunity to practice your technique. This 5-lined skink on a window screen makes a compelling silhouette. (28-70mm zoom lens set at 70mm)

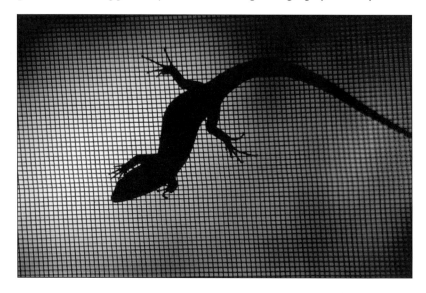

subjects is to get extremely close to them, within three feet or less if possible (see photo 4-12). If you are using a point & shoot camera, you will usually want to use the longest focal length of your zoom lens and photograph at the minimum focusing distance of your lens. For more on this topic, see Chapter Six.

Zoo Photography

Zoos are good places to practice your animal photography. The controlled conditions, the assortment of exotic animals, and the increasing tendency for zoos and wild animal parks to place animals in environments that resemble their natural habitats, make these interesting sites to develop your nature photo skills (see photo 4-13). Just as in the wild, it really pays big dividends to spend a lot of time observing the animals you want to photograph.

If you simply drift from animal enclosure to animal enclosure, pointing and shooting, your pictures will leave a lot to be desired. Instead, take time to get to know the animals you really want to photograph well.

As with photographing animals in the wild, you benefit from learning when the animals are most active, and also when the number of human visitors is lowest. A challenging self-assignment is to try to produce zoo animal portraits that appear as much as possible like photos taken in the wild.

"Zoos are good places to practice your animal photography."

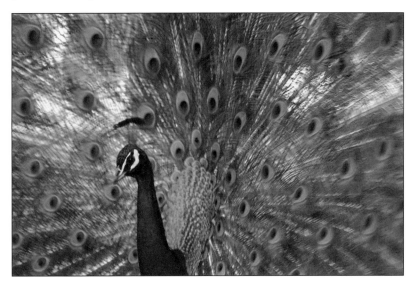

4-13: This peacock was constantly moving while being photographed in low light with ISO 100 film at the Oregon Zoo. In such a situation, focus on the eye and take several exposures to increase your odds of getting one sharp photo. (exposure: 1/30 sec. at f/4.5 with 75-300mm zoom lens)

CHAPTER FIVE

Photographing Landscapes

"...define what is most visually appealing in the landscape."

Framing the Scene

The single most important decision in the process of making a good landscape photograph is determining how to frame the scene. How should you frame a landscape in your camera's viewfinder? A good starting point is to define what is most visually appealing in the landscape.

Why are you drawn to this particular landscape and what do you want to feature prominently in you photograph? Once you have answered these questions, you can zero in on framing the scene so that you do the best job of reproducing the most important features in the landscape, while minimizing the presence of distracting elements in your photo.

In making decisions about how to frame a landscape photo, a zoom lens is very useful since it allows you to expand or tighten your composition without changing your vantage point. Even when you are using a zoom lens, in many cases you can significantly improve a landscape photo by walking to a different vantage point — sometimes by just moving a few feet in one direction — to come up with a better composition.

Once you have decided to photograph a particular landscape, much of the real joy of landscape photography is taking the time to move around and examine the views from different locations. By doing this, you can come up with the optimal composition of the scene, as well as waiting for changes in the natural lighting to enhance the aesthetics.

Placing the Horizon

One of the simplest ways to improve your landscape photos is to be creative with your placement of the horizon in your composition.

5-1: The horizon is placed high in this image of the rising sun peeking over the Blue Ridge Mountains to illuminate the Shenandoah Valley. The result is that the viewer is drawn to the detail in the fog-shrouded landscape. (28-70mm zoom lens)

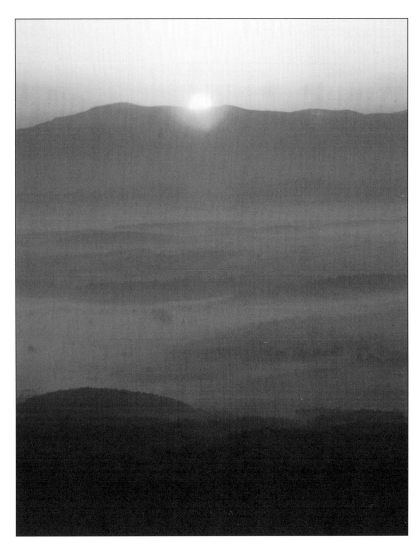

There is a pronounced tendency among beginning photographers to put the horizon at the center of the composition. In some cases this is the best choice, but more often than not you can produce a more compelling landscape photo by placing the horizon higher or lower in the image (see photo 5-1).

You might begin by applying the previously mentioned "rule of thirds" by placing the horizon either one-third of the way down from the top of the image or one-third of the way up from the bottom.

Or you may create a much more interesting image by placing the horizon very close to the top or bottom of the image, or out of the image altogether.

Placing the horizon high in a landscape photo puts primary emphasis on the landscape itself, while placing the horizon low in a photo puts more emphasis on the sky and gives the image a greater sense of spaciousness (see photo 5-2).

Rather than blindly following any particular guideline for horizon placement in your photos, consider what works best in each photographic situation.

5-2: The low position of the horizon in this wide-angle photo of the evening sky in New York's Hudson Valley emphasizes the expansiveness of the sky. The reflections in a pond in the foreground accent the scene. (28-70mm zoom lens set at 28mm)

"Good foregrounds are the spice of landscape photos."

Finding Strong Foreground Elements

The usual approach to composing landscape photos is to devote your attention to "the big picture," putting the emphasis on a wide-angle view of a large landscape, whether the subject is snow-capped peaks, forested hills, or a dramatic seascape. In the desire to put an impressive landscape on film, composing the foreground of the image often receives little attention or is forgotten altogether. Use that foreground!

You can dress up, liven up, and strengthen your landscape photos by composing your landscapes with interesting subjects in the foreground. Good foregrounds are the spice of landscape photos. Frequently all you have to do is slightly reframe your image or move a short distance to get a different perspective with a better foreground.

In addition to adding points of interest to a landscape, strong foreground elements often give the viewer much more of a sense of depth in a photograph; weak foregrounds may leave your landscapes looking flat and uninteresting.

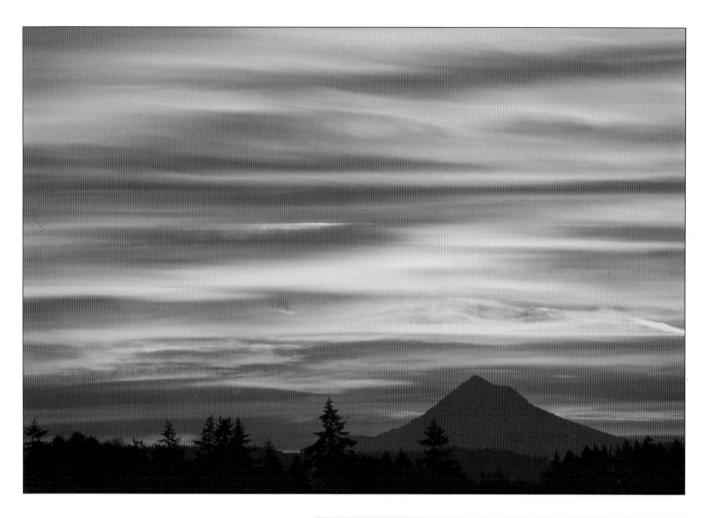

Above: *A fiery dawn sky over Oregon's Mt. Hood makes a strong visual impression. The horizon was placed low in the composition to maximize the brilliant sky. (75-300mm zoom lens)*

Right: *Autumn leaves swirl in an eddy below a small waterfall at Wahconah Falls State Park in Massachusetts. A long exposure gives the falling water a silky appearance and reveals the motion of the floating leaves. (exposure: 6 sec. at f/27 with 28-200 zoom lens set at 40mm and polarizing filter)*

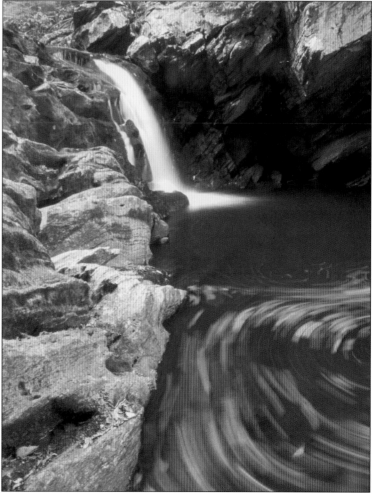

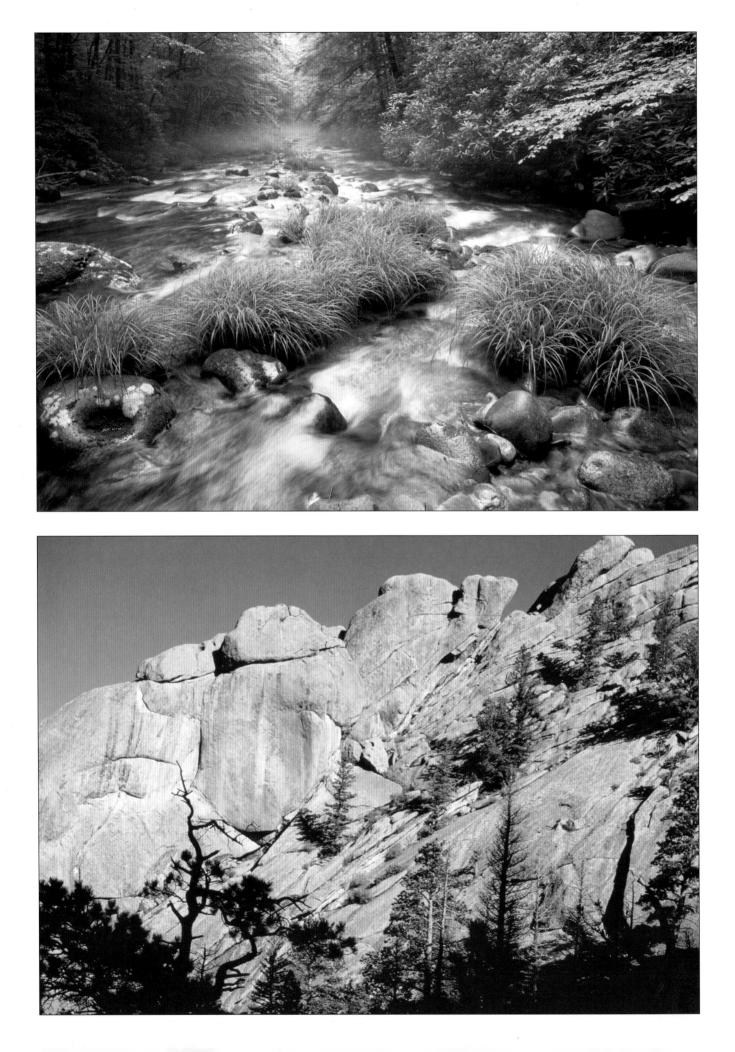

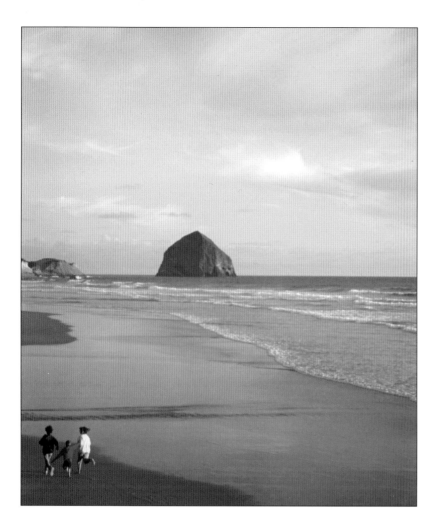

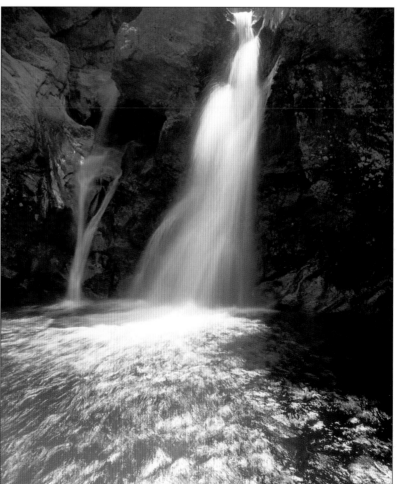

Above: *People add interest and life to landscape photos, even if the people are comparatively small in the image. Late afternoon light accentuates the beauty of this Pacific Northwest beach scene. (28-70mm zoom lens)*

Right: *This photo of a Massachusetts waterfall illustrates the visual power of "filling up the frame" to make the best use of all available space in the image. The key is to take plenty of time looking through the viewfinder to fine-tune your composition. (Medium-format camera with 45mm lens)*

Opposite page, top: *Note how the rocks and sprays of grass in the lower half of the image give this Great Smoky Mountains river scene a sense of depth. Try covering the foreground with your hand to see how different the image would look without the prominent foreground elements. (Medium-format camera with 45mm lens)*

Opposite page, bottom: *Bare rock, blue sky and evergreens complement one another in this Rocky Mountain National Park landscape portrait. (75-300mm zoom lens)*

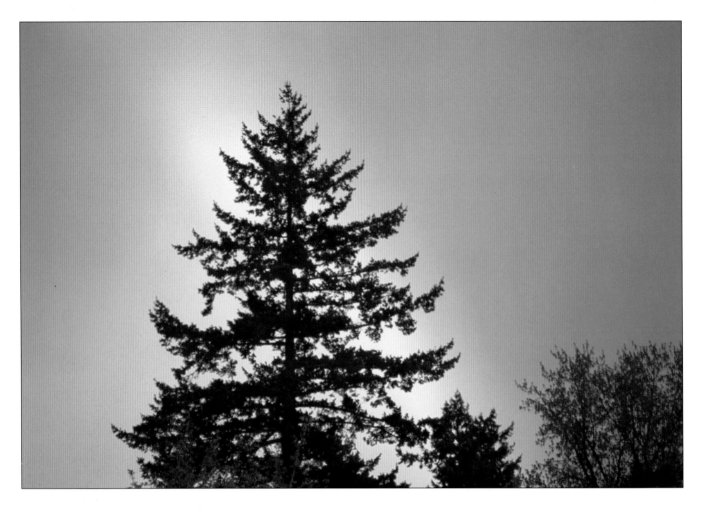

Above: A late afternoon rainbow and a Douglas-fir are the only prominent elements in this photo. When you are composing nature photographs, less is often better! (75-300mm zoom lens)

Right: The best photo opportunities of the day sometimes come before sunrise or after sunset, as in this winter image of a lake in the Allegheny Mountains. The curved shoreline, the high clouds and the combination of "warm" and "cool" colors add visual appeal. (28-70mm zoom lens)

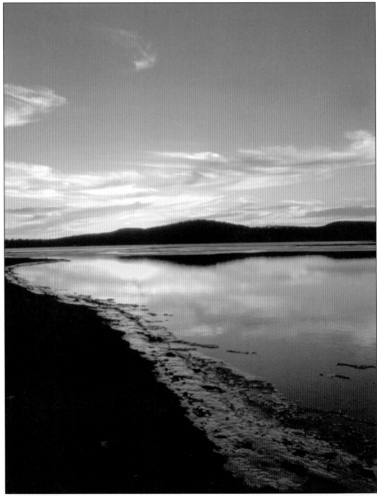

Good foreground subjects in landscape photos do not have to be particularly large; they simply must be visually interesting enough to catch the viewer's eye. This can often be done with a foreground subject that has a striking texture, a repeating pattern, an unusual shape, or a color that contrasts strongly with the more distant landscape elements. You can turn average scenes into superior photographs by spicing up the foreground with eye-catching natural objects such as finely textured shrubs, a patch of alpine wildflowers, or rugged boulders (see photo 5-3).

5-3: The jumble of lichen-covered rocks in the foreground enhance this composition of New Hampshire's Presidential Range. (Medium-format camera with 45mm lens)

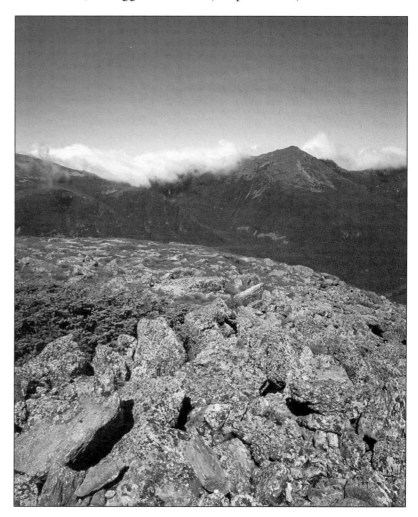

Choosing Lenses for Landscapes

Landscape photography is wonderfully varied since you can photograph landscapes virtually anywhere in any season at any time of day with any type of camera and lens. A great deal of landscape photography is done with **wide-angle lenses**, particularly in the 24mm to 35mm range. With most point & shoot cameras, the short end of the zoom range is 35mm to 38mm, and is well-suited for wide-angle landscape photography. Short to moderate telephoto lenses, especially focal lengths from 70mm to 135mm, are also

useful for landscapes that are not so broad, or for taking "portraits" of landscape features such as a grove of trees, a waterfall or a group of mountain peaks. And longer telephoto lenses of 200mm or even 300mm give you more "reach" to single out more distant landscape features (for instance, a lone tree on a hilltop or a distant rock face). As previously mentioned, zoom lenses are excellent for landscape photography, because they allow you to frame the landscape in a variety of ways from a single position.

Favorite Landscape Photo Subjects

Seascapes

Where land and sea meet, there is the potential for great landscape photos. Coastal landscapes are characterized by continual motion and continual change. There are two rather different approaches to photographing seascapes, based on the particular coastal environment and the photographer's mindset.

One approach is to emphasize the dynamic tension that exists between the irrepressible forces of wind, wave, current and tide and the seeming solidness of the land. This approach works very well on rocky coastlines or on stormy days at the beach. In this sort of photo, it works well to stress motion and the energy of breaking waves making impact on the shoreline (see photo 5-4).

Try to put on film what photographers have long referred to as the "decisive moment" — the climactic instant in which something of great interest happens. The decisive moment may come just as the breaking wave strikes the rocky headland or possibly a split-second later when a thousand fragments of foamy sea water are thrown skyward.

If your camera allows you to manually set shutter speeds, try a relatively fast shutter speed, 1/250 sec. or faster, to freeze the motion in this situation. Strive to make dynamic photos in which the viewer knows the scene lasted for only an instant — the instant you preserved on film in your photo.

A second approach to seascape photography is to bring out the serenity of the coastline. This type of photo comes to mind on a calm day at a wide, sandy beach, particularly in the early morning or late afternoon (see photo 5-5).

In this situation, carefully consider placement of the horizon in your photos, and look for simplicity in composition. Make sure the horizon appears horizontal in your viewfinder; otherwise, your photo will look as if the ocean is draining downhill to one side of the image. Slow shutter speeds, 1/60 sec. or longer, may be useful to blur and soften the motion of waves, thus enhancing a sense of timelessness.

The presence of animals in the landscape will liven up your seascapes. The ubiquitous gulls on the beach, flocks of little shorebirds skirting the water's edge, and larger birds such as pelicans and cormorants in flight bring seascapes to life.

Quick Tips

Decisive moments are those climactic instants in which something of great interest happens. Try to capture these moments on film.

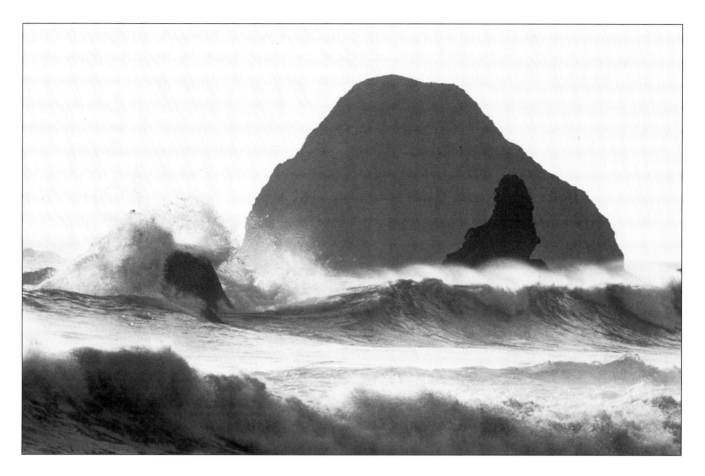

5-4 (above): This photo emphasizes the power and wildness of the northern California surf on a windy day. The noticeable graininess of fast film (ISO 400) accentuates the elemental look of this image. (180mm lens)

5-5 (right): A quiet morning on Virginia's Atlantic coast is ideal for this calm seascape. Notice how your eye is drawn to the lightest tones in the photo, and how the sandy area in the lower right helps balance the image and gives a sense of depth. (28-70mm zoom lens)

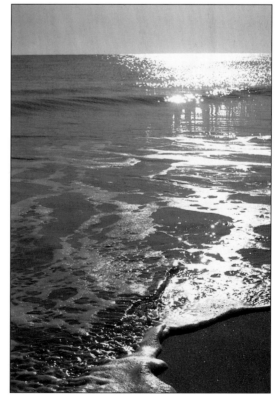

"Snowy and icy landscapes are ideal for photographs with pronounced textures..."

5-6: A Pennsylvania ice storm created this glittering forest landscape. The photo was composed so that the bright sun was partially obscured behind trees to prevent the sunlight from overpowering the scene. (28-70mm zoom lens)

Snowy Landscapes

Snowy and icy landscapes are ideal for photographs with pronounced textures, interesting patterns, and strong contrasts between light and dark. Some of the best photo opportunities are immediately after a fresh, heavy snow or an ice storm (see photo 5-6). However, snowy landscapes can be problematic in terms of exposure. As described in the chapter on exposure, your camera's exposure meter works fine when the scene you are photographing is largely made up of middle tones, intermediate between black and white. This is true in many landscapes, particularly those dominated by green foliage. But what about a snow-covered landscape, especially a sunlit one? In this case, the average tone of the landscape is far lighter than a medium gray. Consequently, photographs of bright, snowy landscape photos often come out grayish — not white — because they are underexposed compared to the actual scene.

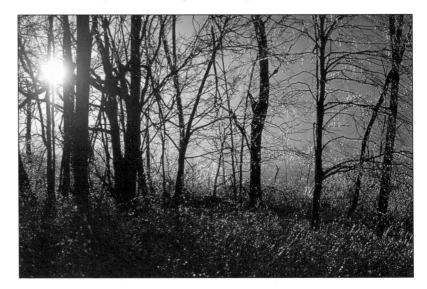

When photographing snowy landscapes, you would do well to apply the aforementioned adage, "add light to light." If your camera has manual exposure control, overexpose between 1/2 and 2 stops compared to the reading your exposure meter indicates. Experiment with your camera to determine what works best for you. If you have a point & shoot camera, then you may use the camera's backlight compensation feature to produce lighter images. Some professional nature photographers prefer photographing snowy scenes on overcast days or in low-light situations when there is much less contrast in the scene and the exposure is less problematic.

Wetlands Landscapes

Though wetlands were historically viewed as wastelands, these marshes, swamps and bogs are among the most biologically productive ecosystems on earth and are beautiful photographic subjects (see photo 5-7). Wetlands are chock-full of wildlife, particularly birds and amphibians. The appearance and life of wetlands change

5-7: Reflections of sky, clouds and grasses in an Oregon marsh illustrate the intrinsic beauty of wetlands. Consider the simplicity of the composition. (28-200mm lens)

5-8: Photographing from a higher vantage point creates an aerial perspective in your photos of flat wetlands. This winter image of a Maryland marsh accented by Canadian geese was taken at dusk from an observation tower. (70-210mm zoom lens)

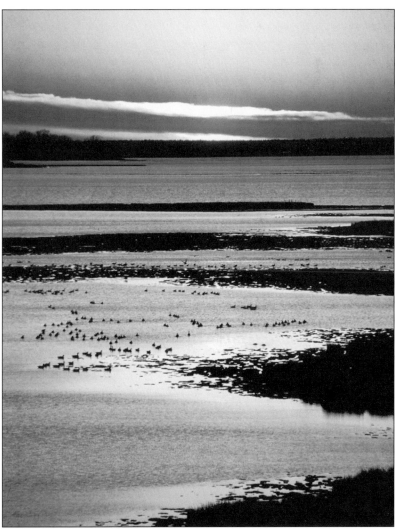

greatly with the seasons. Major changes in the wetlands landscape are brought about by the migrations of waterfowl, wading birds, and songbirds; cycles of grasses and other plants growing, blooming

and dying back; and seasonal variations in rainfall, temperature and water level. For example, autumn rains may seasonally flood a wet meadow, then winter cold may turn it into a frozen marsh.

To get memorable wetlands photos, learn the daily and seasonal cycles of your local wetlands. Be in position to photograph at dawn and dusk, when marshes, swamps and bogs are at their liveliest and the warm light accents the natural beauty. Wetlands by nature are flat, and are usually viewed from ground level, so anything you can do to get a higher-angle perspective will make for a more unusual and interesting photograph (see photo 5-8). For example, an adjacent hill or bluff, a birding observation tower, or even a tree you can climb, will give you a higher vantage point for your wetlands photos and more compositional choices. In your wetlands images, make good use of reflections, prominent textures and repeating patterns, and strong lines such as shorelines or boundaries between marsh and forest. Also look for wildlife to accent your wetlands landscapes; a solitary heron or pair of egrets or a small flock of waterfowl can bring a marsh scene to life.

Forest Landscapes

America's vast and diverse forests — from the yellow pine woods of the South to the Appalachian oak forests, the great Northern hardwood forests, and the spruce-fir forests of high elevations and northerly climes — offer a wealth of nature photo opportunities.

5-9: This wide-angle view of New York's Shawangunk Mountains emphasizes the wild beauty of the forest landscape. The white cliffs at the lower right provide an interesting visual counterpoise. (Medium-format camera with 45mm lens)

5-10: *This forest portrait was taken in the Taconic Mountains on the border of Connecticut and New York. Notice the visual appeal of the series of small, white birch trunks on the left and the much larger, darker tree trunks on the right side of the image. (Medium-format camera with 135mm lens)*

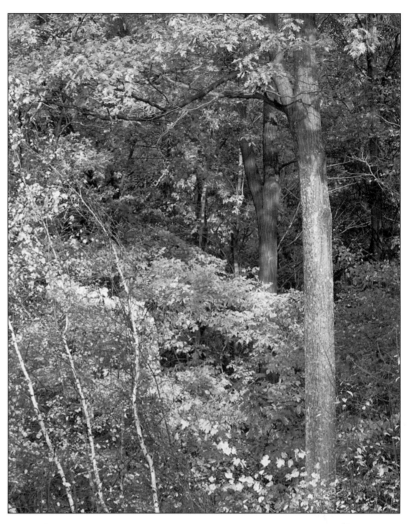

5-10: *This forest portrait was taken in the Taconic Mountains on the border of Connecticut and New York. Notice the visual appeal of the series of small, white birch trunks on the left and the much larger, darker tree trunks on the right side of the image. (Medium-format camera with 135mm lens)*

"Give careful consideration to horizon placement in your forest landscape photos…"

Two complementary strategies for putting forest landscapes on film are the "big-picture" approach and the "portrait" approach. In essence, the big-picture approach involves looking at the forest from the outside, that is, from above the forest canopy or treetops. The portrait approach is an inside view of selected forest features underneath the forest canopy.

To use the big-picture approach, find a vantage point with a sweeping view of the forest — typically an overlook, clearing, hilltop or mountain summit — and use a wide-angle lens to photograph the forest expanse.

Give careful consideration to horizon placement in your forest landscape photos; if you want to really emphasize the forest, then you may want to put the horizon near the top of the image or out of the image altogether (see photo 5-9). If you are photographing a forest landscape in hilly or mountainous terrain, then try vertical compositions to portray the vertical relief in the landscape. From a forest overlook, you may also want to use a telephoto lens to focus in on particularly notable features of the forest landscape, such as a bare cliff, a grove of particularly tall trees or a patch of showy autumn foliage.

The portrait approach can be applied virtually anywhere in a forest. This approach works well while hiking on forest trails. Choose a short-to-moderate telephoto lens in the 70mm to 135mm range, and take some time looking through your viewfinder to pick out the most visually interesting forest subjects.

Look for aesthetically pleasing compositions that tell the visual story of the forest in a nutshell (see photo 5-10).

For example, you might choose to focus on the parallel lines of tree trunks that have strikingly colored or textured bark, such as aspens, sycamores, paper birches, or ponderosa pines.

Or you may frame a forest portrait emphasizing a lone patch of sunlight — lighting up a boulder, a patch of wildflowers or berry-covered brambles — that stands out within the shaded confines of the forest.

Running and Falling Water

My personal favorite nature photo subject is fast-moving water in rivers, streams and waterfalls. Photographing the dynamic nature of running and falling water is a creative challenge and a joy. If you can manually set shutter speeds on your camera, then you may

5-11: A long exposure of white water in the Great Smoky Mountains gives a soft, airbrushed effect to the water. For this sort of effect, stop you lens down to one of its smallest apertures such as f/16 or f/22, and use shutter speeds of 1/15 sec. or longer. (Medium-format camera with 45mm lens)

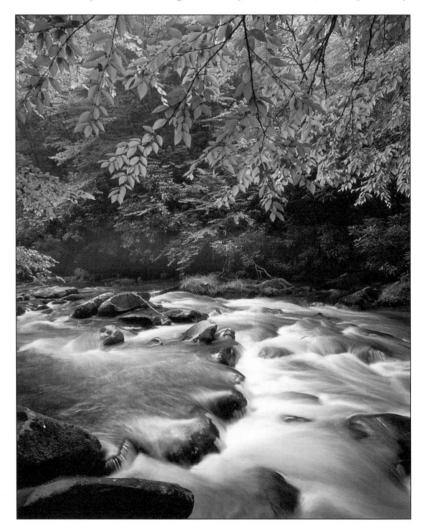

"Rivers and streams can be photographed well in a variety of ways."

choose to either freeze the water's motion for a tiny fraction of a second in time or you can gather light for a period of a full second or more — a long time photographically — and thus create a time-mosaic image of water motion that goes well beyond anything the naked eye can see (see photo 5-11).

Rivers and streams can be photographed well in a variety of ways. From one location alongside a river, you can make very different photographs by looking upstream, downstream and across the river. When you are on the banks of a river with riffles or rapids, composing photographs looking upstream is often easiest. If a stream is flat and slow-moving, finding a higher vantage point from which to photograph will often produce more interesting compositions. To compose photos in which a watercourse is an element in a wide-angle landscape, consider how to best use the linear form of the river to enhance the aesthetics of the landscape; remember that curved or diagonal lines can serve as strong compositional elements.

When you are photographing waterfalls, try to create something more interesting than the standard postcard view that everyone else

5-12: This unusual image of a small Shenandoah Valley waterfall was taken from a vantage point on the side of the falls. Notice the visual balance between the maple leaves on the left and the heavy rock face on the right. (exposure: 1/2 sec. at f/16 with 90mm lens)

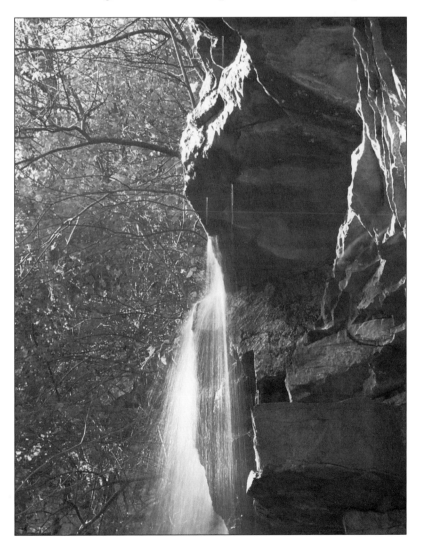

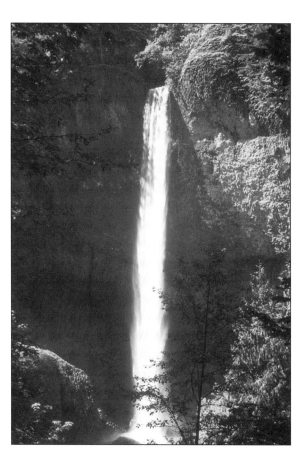

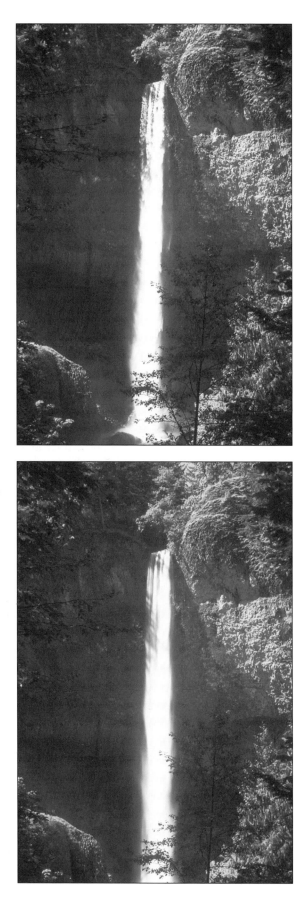

5-13, 5-14 & 5-15: Compare these waterfall photos taken in the Columbia River Gorge in Oregon. The shutter speeds were: 1/125 sec. at f/5.6 (upper left); 1/30 sec. at f/11 (upper right); and 1/6 sec. at f/27 (lower left). The photo in the upper left shows the most definition in the falls; the slow shutter speed in the lower left photo produces a silky effect. (28-200mm zoom lens set at 50mm)

> "... take time to move
> around and check
> different perspectives
> through your viewfinder."

photographs. After arriving at a waterfall, take time to move around and check different perspectives through your viewfinder. One compositional formula for waterfall photos is to show where the water is coming from above the falls and where the water is going to below the falls; however, in some cases you may want to zoom in or move closer and just show a portion of the falls (see photo 5-12). In composing waterfall photos, make sure that the water appears to be falling vertically in your images, unless you are trying to create an abstract effect.

More than most any other landscape feature (with the possible exception of an erupting volcano!), the appearance of waterfalls in photos depends on the photographer's choice of shutter speed. If you can manually set shutter speeds on your camera, keep in mind that fast shutter speeds, usually 1/500 sec. or faster, will freeze the motion of the falls with individual droplets of water captured in mid-air. Slow shutter speeds of 1/15 sec. or slower tend to reproduce the falling water with a silky, "cotton-candy" effect. The longer the exposure, the more pronounced is this silky smoothing of the falls. Shutter speeds between approximately 1/30 sec. and 1/125 sec. typically produce an intermediate effect, where some motion is shown, but not enough to totally smooth out the falling water (see photos 5-13, 5-14 and 5-15).

Even if you cannot manually set shutter speeds on your camera, you do have a degree of control over the way your waterfall photos will appear. When you photograph bright scenes, such as a sunlit waterfall on a summer day, with fast film (ISO 400, for example), your camera will automatically choose a fast shutter speed. But if you are photographing scenes in low light with slower film (ISO 100, for example), then your camera will select a slow shutter speed.

Sunrises and Sunsets

Everyone seems to love beautiful sunrises and sunsets. The trick is to figure out how to put them on film! For starters, there is a tendency for the automatic flash on point & shoot cameras to fire when you photograph sunrises and sunsets. Your flash will not light up the landscape; in fact, your camera's microchip brain may alter the exposure to compensate for the flash, and the landscape will be underexposed. Unless you are trying to illuminate an object within 15 feet of you, set your camera to its "flash-off" mode, to make sure the flash is not activated in this situation.

A particularly important consideration for sunrise and sunset photos is where to place the horizon in the photograph. Putting the horizon very close to either the top or the bottom of the image frequently works well. If you want to emphasize the sun, brightly lit clouds, and the expansiveness of the sky, then putting the horizon very low in the image is a good choice. On the other hand, if the landscape has extremely interesting elements, for instance, a herd of elk grazing or a carpet of wildflowers stretching into the distance, then placing the horizon near the top of the image makes sense.

5-16: The most interesting light of the day for landscape photography is often at dawn or dusk as in this image of afterglow in the western sky following a Montana sunset. The horizon was placed low to emphasize the vastness of the sky. (38mm lens)

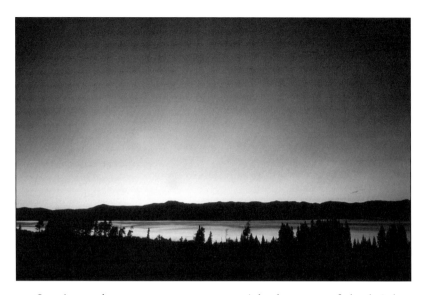

Sunrise and sunset exposures are tricky because of the brightness of the sun and the very high contrast between the light sky and the much darker landscape. One of the most common disappointments with these photos is that the bright sun overwhelms the camera's exposure meter so that the sun is visible in the photo but the land appears almost black. Once again, as in the case of photographing snowy landscapes, you are dealing with a situation where it works well to "add light to light" in setting your exposure. If your camera has manual exposure control, overexpose between 1 and 2 stops compared to the reading your exposure meter indicates. The brighter the sun appears and the more prominent it is in your photo, the more intentional overexpose you will need. Experiment with your camera and favorite film to determine what works best in situations you commonly encounter. If you have a point & shoot camera, then try using the camera's backlight compensation feature in some of your photos to produce lighter images of sunrises and sunsets.

If you are intent on photographing beautiful skies, make it a point to be in the field by dawn and linger until dusk (see photo 5-16). Depending on weather, topography and atmospheric haze, the most beautiful light is sometimes as much as 45 minutes before sunrise or after sunset. When photographing sunrises and sunsets, always keep in mind that a camera's viewfinder does not protect your eyes from the sun; never stare directly at the sun while composing sky photos.

Aerial Photos

Photographing landscapes from the air is a great way to produce unique images. And, no, you do not need to own your own airplane to do this. Whether you fly commercially twice a month on business or only once every few years on a vacation, with a few guidelines you can get excellent aerial photos. First, the basics: If you want to photograph on a commercial flight, request a window

"Photographing landscapes from the air is a great way to produce unique images."

seat that is well in front of or well behind the wing. Keep in mind that in flight you are moving very fast, often 500 mph or more, relative to the ground below, so slow shutter speeds will result in blurry pictures. If you are manually setting exposures, select 1/250 sec. or faster when possible. Use medium-to-high speed films, ISO 200 or 400, unless the lighting is extremely bright. For the best light, as with all landscapes, it usually pays to fly quite early or late in the day (see photo 5-17). In particular, avoid the harsh lighting of midday on summer days.

Line up your aerial photos with the front element of your lens as parallel to the window as possible. On commercial aircraft, you are usually photographing through two panes of scratched plexiglass, and if the front of your lens is not parallel to the window, you will typically see significant blurring in at least part of the image. Also try to place the lens as close to the window as you can (flush to the window is best) to avoid picking up reflections on the inside of the window.

Do not use flash — it will bounce off the window and ruin your photos, but will not light up the world below. If your camera automatically activates your built-in flash, override it with your "flash-off" mode.

Be careful if you are using a **polarizing filter** as it may create psychedelic bands of color when photographs are taken through airplane windows; this is fine for creative, surrealistic photos but not for natural-looking images.

Finally, at cruising altitudes 6 miles or more above the earth's surface, natural atmospheric haze and air pollution make it difficult to get sharp photos even on clear days. So try to photograph at relatively low altitudes soon after take-off or shortly before landing.

5-17: A late afternoon image of Oregon's Mt. Hood wearing a cloak of clouds exemplifies the beauty of aerial photography. When flying, use a relatively fast shutter speed, 1/250 sec. or faster, if possible, since you are moving over your subject — the earth — at a very high rate of speed. (28-200mm zoom lens)

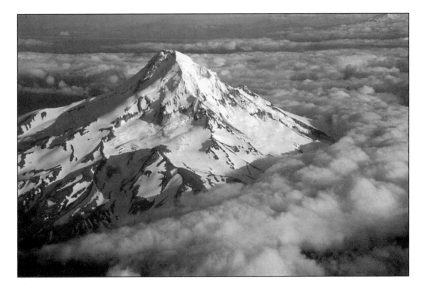

Photographing Wildflowers & Other Close-ups

Get as Close as You Can

Close-up photography is one of the most challenging areas of nature photography — exposure, composition and focus are all critical variables in producing a successful close-up. Powerful close-ups are visually appealing because the subject appears so large that you can see features that are not readily apparent to the casual observer of nature (see photo 6-1).

An essential first step toward success in your close-up photography is to find out how close your lenses allow you to get to your subject while still being able to focus. This distance, which varies from a few inches to several feet depending on the lens, is known as the **minimum focusing distance** of your lens. The maximum size at which you can reproduce your subject on film depends on the minimum focusing distance and the focal length of your lens. A common beginner's mistake is to attempt to photograph flowers and other small objects from so closely that the lens cannot focus. The result is a blurred photo.

You can determine minimum focusing distance by checking the owner's manual that came with each of your SLR lenses or your point & shoot camera. A more meaningful way to determine minimum focusing distance is by simply focusing on a stationary object — tree bark, a flower, a stone — and moving closer and closer until you can no longer get the lens to focus. If you are using an SLR, you can tell you are too close to focus when the image in the viewfinder is blurred even with the lens set at the minimum focusing distance. If you are using most point & shoot cameras,

"...find out how close your lenses allow you to get to your subject while still being able to focus."

6-1: *For strong close-up photos of small flowers, get absolutely as close to the subject as your equipment will allow, and focus precisely. Photographing from ground level, even these tiny bluets look large. (70-210mm zoom lens set at 210mm with +3 close-up supplementary lens)*

you can tell you are too close to focus when you depress the shutter release halfway — to activate the autofocus — but the focus-confirmation light will not come on in your viewfinder. The minimum focusing distance of most point & shoot cameras is somewhere between 2 and 4 feet.

Two other points pertaining to close-up photography with point & shoot cameras are worthy of mention here; it is a good news, bad news scenario. First, the good news is that some point & shoot cameras have a close-up or "macro" mode that allows the camera to focus closer than it otherwise could. Check your owner's manual to see if your camera has this feature. Second, the bad news is that the viewfinder on a point & shoot is separate from the lens; when you look through the viewfinder, you are not viewing through the lens as on an SLR. Consequently, at close focusing distances, there is a substantial difference between the image the camera "sees" and the image you see. Follow guidelines given in your point & shoot owner's manual about using special close-up framing lines that are visible in your viewfinder to compose your close-up photos.

Equipment for Getting Closer

If you have an SLR camera and are serious about doing close-up photography, there are three types of close-up equipment you may want to use: a macro lens, supplementary close-up lenses, and extension tubes. A **macro lens** is a useful acquisition. Macro of course means large — a macro lens is a lens that allows you to make your close-up photo subjects appear large in your photos. Such a lens allows you to focus so close to your subjects that you can produce photos of your subjects that are at least one-half life-size on the slide or negative. Many macro lenses allow you to get so close to your subjects that you can photographically reproduce your subjects at life-size. For example, if you photographed a flower that was one inch in diameter, then the flower's image is reproduced one inch in diameter on the slide or negative, and it fills up the full width of the photo (see photo 6-2).

6-2: This rose was photographed at life-size with a 90mm macro lens. Notice how limited the depth of field is at such close range, despite the fact that the lens was stopped down to f/32 to maximize the zone of sharpness.

Be aware that many of today's zoom lenses are loosely marketed as "macro zooms," but do not provide true macro performance. In many cases, these lenses do not allow you to reproduce your subjects at greater than one-fourth life size. Before purchasing such a lens with hopes of doing close-up photography, try it out in a camera store and see for yourself how close it will focus.

For SLR camera users, an inexpensive alternative to a true macro lens is a **supplementary close-up lens**. This looks like a clear filter and screws on to the front of any other lens. A supplementary close-up lens has the effect of reducing the minimum focusing distance of the lens to which you attach it (see photo 6- 3). Supplementary close-up lenses are far less expensive than a good macro lens and are much easier to carry in the field. Supplementary close-up lenses are often sold in sets of three and have varying strengths measured in diopters such as +1, +2, +3, and +4. For example, a +3 will allow you to focus closer than a +2. You can simultaneously attach two or more supplementary close-up lenses to your lens, allowing you to

Quick Tips
Supplementary close-up lenses reduce the minimum focusing distance of the lens to which you attach them. They are far less expensive than a good macro lens and are easier to carry in the field.

Above: Dogwood leaves are silhouetted against the setting sun in this simple composition. The minimal depth of field — a product of a large aperture, a long focal length and a close focusing distance — is useful to place full emphasis on the silhouetted leaves. (exposure: 1/180 sec. at f/4 with 70-210mm zoom lens set at 210mm)

Right: Notice the application of the rule of thirds in the off-center placement of the yellow iris in this image. (28-70mm zoom lens)

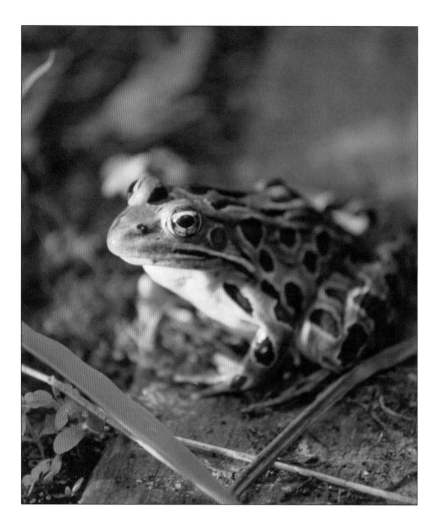

Above: *The warm light of a Vermont summer evening accentuates the striking pattern of this leopard frog. At such close range, depth of field is minimal, so it is crucial to focus on the frog's eyes. (28-70mm zoom lens set at 70mm)*

Right: *Look for interesting foreground elements to strengthen the appeal of your wide-angle landscape scenes such as this Montana Lake. Note the very high placement of the horizon and the visual prominence given to the reflections. (28-70mm zoom lens)*

Opposite page, top: *A young wild pony in Virginia's Chincoteague National Wildlife Refuge makes for an easy exposure situation. Your camera's exposure meter is calibrated to correctly read the dominant middle tones of the sunlit meadow in this low-contrast scene. (70-210mm zoom lens)*

Opposite page, bottom: *Raindrops left behind after an October storm heighten the visual appeal of fallen leaves in a New Hampshire forest. (Medium-format camera with 135mm macro lens)*

Left: *A Berkshire forest lights up with the brilliant, ephemeral colors of a New England autumn. Overcast days are often the best for capturing such vivid natural colors on film. In direct sunlight, autumn foliage photos often appear less intense or even "washed out." (Medium-format camera with 135mm lens)*

Below: *An overgrown field on an old Hudson Valley farm hosts a mixture of purple loosestrife and goldenrod. When composing flower photos, look for interesting color combinations. (Medium-format camera with 135mm lens)*

6-3: This close-up portrait of wet redbud blossoms was made possible by attaching a +3 supplementary close-up lens to a 70-210mm zoom lens.

focus even closer, but doing so can noticeably degrade image quality. Thus using only one supplementary close-up lens at a time is a good idea, unless you absolutely need to focus closer to your subject.

Another approach to getting closer to your subjects without the expense of a macro lens is by using **extension tubes**. These are hollow plastic or metal cylinders that you mount between your camera and lens. Extension tubes have the effect of reducing the minimum focusing distance of whatever lens you attach them to. They are sold individually or in sets of three of varying lengths, and you can attach one, two or three at a time. The more extension, the closer your lens can focus to your subject, hence the larger you can reproduce your subjects on film. A set of extension tubes is typically more expensive than a set of close-up supplementary lenses, but considerably less expensive than a good macro lens. Unlike use of multiple supplementary close-up lenses, using extension tubes does not degrade your image quality.

Depth of Field & Focusing

In close-up photography, depth of field is important. Why? Because when you focus on subjects very close to your camera, depth of field — the range of distances, from near to far, that appears sharply focused in a photo — is minimal.

The closer you focus, the less depth of field you have. The total zone of sharpness in a close-up photo may only extend from a fraction of an inch in front of the subject on which you are focused to a fraction of an inch in back of the subject (see photo 6-4).

Because depth of field is so limited in close-up photography, accurate focusing is absolutely crucial. For sharp close-up photos, follow these three guidelines:

1. Focus precisely on the most important part of your subject.

6-4: This photo of chicory illustrates the minuscule depth of field in photos taken at extremely close range. Accurate focusing and a stable tripod are essential to ensure a sharp photo. (60mm macro lens)

2. Make the camera as stable as possible. Use a tripod for close-up photography whenever you can.

3. If you can manually set exposures on your camera, consider using a small aperture, $f/16$ or smaller, to enlarge your depth of field.

Square Up to Your Subjects

Another key to coping with the very limited depth of field in close-up photography is to "square up" to your photographic subjects whenever possible. In simple terms, this means to try to line up your camera so that your lens is pointing at a right angle to the most important elements of your photo.

You might want to visualize this situation by thinking of the film in your camera being parallel to the most important plane (two-dimensional surface) in the scene you are photographing. This technique is a way of maximizing the amount of the image that will appear within your limited depth of field and thus in focus (see photo 6-5).

Of course, you do not want to take this technique to such an extreme that you give up a striking composition for the sake of keeping more of the image in focus. Many great close-up photos are selectively focused on only a small portion of the image, and the remainder of the photo is intentionally out of focus.

6-5: In this study of fallen leaves in Massachusetts, the goal was to get the entire image sharply focused. To "square up" the camera to the leaves, the camera was set up on a tripod directly above the leaves, with the lens aimed straight downward. (Medium-format camera with 135mm macro lens)

Using Flash

The vast majority of nature photography is done with "ambient" (naturally available) light, but a flash can often be used to enhance close-up photographs. In particular, you may want to use flash to photograph wildflowers in situations where light levels are too low to photograph without flash or in situations where your flash can "fill-in" light in shaded areas of your close-up scene.

In close-up photography, you should be careful not to overpower the image with flash. Too much flash may overexpose or "wash out" your close-up subjects and/or leave the underexposed background unnaturally dark. Modern flash units, as well as some built-in flashes on SLRs and point & shoot cameras, give you the option of toning down your flash's output so as not to overdo the artificial lighting. The goal of using flash in close-up nature photography is typically to enhance the image without the lighting looking overly artificial or surreal. The best way to learn how to do this is to experiment with your particular equipment — whether you use a point & shoot camera or an SLR — by trying out your

Quick Tips

Be careful not to overpower your close-up subject with a flash. Too much flash may overexpose your subject and/or leave the background dark.

flash's settings or modes in a variety of natural lighting situations and subject-to-camera distances. For cameras with built-in flash units, the camera owner's manual contains valuable information on how to use various flash modes and on the effective distance range of your flash. Write down what you do on each flash exposure and carefully evaluate your photographic results.

Simple Tricks to Improve Lighting

Even without using a flash, there are a number of easy ways — using very inexpensive accessories — to improve the lighting for close-up photography by either reflecting or diffusing naturally available light.

One of the most popular lighting reflectors for nature photographers is aluminum foil. It is inexpensive, easy to use, reusable and even recyclable. You can make versatile reflectors by covering sheets of cardboard, from the size of an index card on up to the size of a legal pad or larger, with aluminum foil. Thoroughly crumple the foil — the creases and lines in the foil will soften the reflected light — then straighten it out prior to taping or stapling it to a cardboard sheet.

Some photographers don't even bother with the cardboard, and simply carry folded or rolled sheets of aluminum foil into the field. The cardboard is simply a practical way to hold the foil rigidly, and the cardboard can be balanced in a bush or in high grass, propped against a tree trunk, or suspended by twine from a tree limb.

Foil reflectors are useful for bouncing natural light just where you want it in close-up photos. For example, if you are photographing wildflowers in the forest on an overcast day, minimal ambient light may reach the flowers. But you can position one or more foil reflectors on the ground or in underbrush near the flowers at such an angle that the foil bounces light from the sky onto your photo subjects. Make sure the reflectors are not in the image.

Using this technique, you can often at least double the amount of light on wildflowers you are photographing.

Another good accessory to either reflect or diffuse light is a rectangular automobile sunshade made of nylon or other synthetic fabric with a flexible metal frame. These shades usually fold to fit into a small, circular cloth case and spring open to a much larger size such as 24"x28" when removed from the case. They not only help keep your parked car cool on a sunny day, they are also an excellent nature photo field accessory. They are inexpensive (often less than $10), lightweight and durable. These shades are often sold in pairs; they come in a variety of colors and sizes. An ideal shade is silver (or white) on one side and gold on the other side; the silver side provides "cool" lighting, while the gold side gives a "warmer" cast to your photos.

In close-up photo situations, you may either prop or hold these shades in position to bounce skylight onto your photo subjects, or you may use them to shade or diffuse direct sunlight that is bathing

your subjects in overly bright, contrasty light. If you prefer, you can purchase excellent flexible diffuser-reflectors that are made specifically for photography, but they may cost at least several times as much as car sunshades. Some other inexpensive ways to diffuse direct sunlight are to block the sun with a white umbrella, strips of cheesecloth or any thin, white cloth.

Flower Photo Tips

To truly enjoy wildflower photography, get to know the wildflowers where you live. In most temperate regions, the wildflower world is an ever-changing, visual smorgasbord of photographic offerings from early spring through summer and on into late autumn (see photo 6-6). Learning where and when to look for the seasonal wildflower highlights of your bioregion is half the fun of wildflower photography. Beyond photographing wildflowers in truly wild or natural settings, consider opportunities to photograph ornamental flowers, shrubs and blooming trees in lawns, gardens, commercial greenhouses, and municipal parks.

6-6: This skunk cabbage in an Oregon marsh looks a lot better than it smells. Skunk cabbage is among the early bloomers that alert wildflower photographers can find in March while many areas are still snow-covered. (28-70mm zoom lens set at 70mm)

"...use a fast shutter speed to freeze the motion of moving flowers in your photos."

Once you have found the ideal flowers to photograph, you are often faced with a potentially frustrating situation: a breeze is blowing the wildflowers, and they won't stand still for a picture. The closer you are to your subject, the larger it appears in your viewfinder, and the more likely that you will have blurred flowers in your photos. What to do? If your camera has manual exposure control, then use a fast shutter speed to freeze the motion of moving flowers in your photos.

If the lighting allows you to use a shutter speed of 1/250 sec. or faster, that's great; if not, use the fastest shutter speed you can to increase your odds of freezing the motion on film. Whether or not you have manual exposure control, you can use one or more of the following techniques to increase your chances of producing sharply focused flower photos in a moving-flower situation:

1. Shield the flowers from the breeze with your body, a friend, a windbreaker or a piece of cloth.

2. Use moderate-to-high-speed film — ISO 200 or 400 — so that faster shutter speeds are possible.

3. Use one of the reflector accessories mentioned in the previous section to bounce more natural light onto the flowers.

4. Use a flash.

5. If all else fails, be patient — the breeze will eventually stop.

Flowers offer special challenges in terms of exposure. A common problem in flower photography is when you have small, light-colored flowers in direct sunlight against a darker background, say, shaded green leaves or grass. This often leads to overexposed, washed-out flowers in your photos, particularly if you are using slide film. If your camera has manual exposure control, then either intentionally underexposing (approximately one stop) or taking a spot meter reading directly off of the flowers may work well. If you are using a point & shoot camera, your best bet may be to shade the flowers or diffuse the lighting using one of the accessories mentioned previously, or wait to photograph when there is not bright sunlight on the flowers.

One of the simplest ways to improve your flower photos is to position your camera near the ground. Mounting your camera as low as you can on your tripod — or hand-holding the camera while you are on your knees and elbows or you are laying flat on the ground — will provide a much more interesting perspective for many of your close-up photos. For some really unusual images, get down so low that you are looking up at the flowers, with the sky in the background.

Other Favorite Close-Up Photo Subjects

Nature is full of objects that have intriguing textures, patterns and color combinations when viewed from close range. Seed pods, berries, tree bark, mosses, lichens, driftwood, rocks, and fallen leaves or cones make superb close-up photo subjects. With each of these subjects, you can easily produce interesting abstract compositions dominated by textures and repeating patterns.

If you are out in the field with the urge to take close-ups on a windy day when the wildflowers are dancing in the breeze — and would thus appear as a blur in your photos — consider photographing stationary objects like stones and tree bark (see photo 6-7). The ever-changing ripple marks in sand that you can find on dunes, beaches or stream banks are another favorite subject for close-ups that can make stunning abstract photos.

6-7: The scaly, jigsaw-puzzle bark of a ponderosa pine in the Cascade Mountains makes an appealing close-up subject. This photo was taken in late afternoon sunlight; the shadows and slight variations in tone of the bark add interest to the image. (Medium-format camera with 135mm macro lens)

Nature Photo Equipment

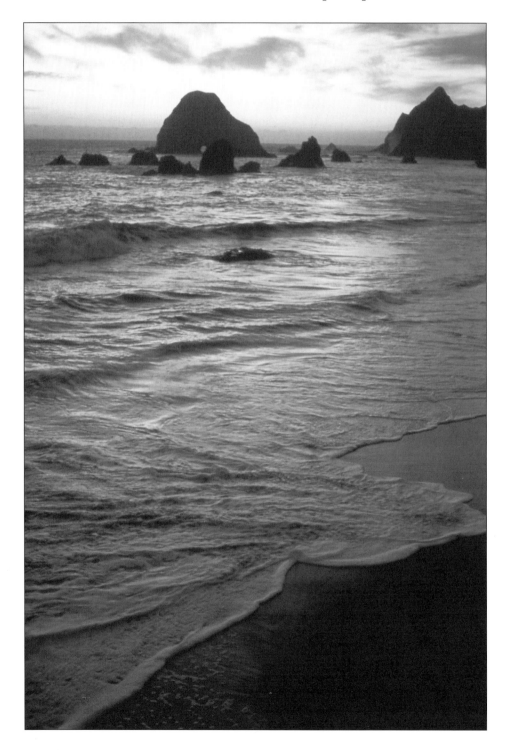

Cameras, Lenses & Field Gear

35mm Cameras

By far, the most popular cameras for nature photography are those that use **35mm film**. The name 35mm camera refers to the fact that each image produced on the film used by these cameras is approximately 35mm (about 1-1/2 inches) in length. The two basic varieties of 35mm cameras are single-lens-reflex cameras, usually called SLRs, and point & shoot cameras.

SLRs

Three features make SLRs the first choice for most intermediate or advanced nature photographers:

1. The lenses are interchangeable; you can use a wide variety of lenses on virtually any name brand 35mm SLR.

2. The viewfinder of an SLR allows you to look through the lens, thus the image you see is a very close approximation of the actual image your film will "see."

3. Most SLRs allow for partially or completely manual control of exposure for fine tuning your images or coping with difficult lighting conditions. Most SLRs also give you the choice of autofocus or manual focusing of the lenses.

Point & Shoot Cameras

Point & shoot refers to an assortment of 35mm cameras that are compact, automatic, and have built-in lenses. Point & shoot cameras are extremely popular among beginning nature photographers because they are relatively inexpensive, small, lightweight,

Opposite page: The wide-angle lenses of point & shoot cameras are excellent for photographing expansive landscapes such as in this image of California's spectacular Sonoma coast. (38mm lens)

"In many situations, you can produce excellent nature photos with a point & shoot camera..."

and easy to carry. In addition, they autofocus, automatically set the exposure, and have built-in flash. In many situations, you can produce excellent nature photos with a point & shoot camera, without carrying a lot of camera equipment or learning a lot of technical information. However, point & shoot cameras have several notable drawbacks:

1. The vast majority of point & shoots lack manual control of exposure; this is a major disadvantage if you shoot color slide film, which has little tolerance for exposure errors, or if you face difficult lighting situations.

2. Lenses are not interchangeable on point & shoots; you are limited to the lens — usually a zoom lens — that is built into the camera. Long telephoto lenses for wildlife photography are not available, so you must be quite close to animals to produce good wildlife portraits.

3. As mentioned in Chapter Six, close-up photography is hindered because point & shoots will not autofocus on subjects that are extremely close. Also, the viewfinder is completely separate from the lens, so when you take close-ups, there is a significant difference between the image the camera sees and the image you see. This makes composition of close-ups quite difficult because what you see is not exactly what you will get.

These reservations aside, point & shoots are suitable for lots of everyday nature photo situations (see photo 7-1). In particular, they are good for photographing well-lit landscapes, as well as for situations such as white-water rafting, cross-country skiing, trail running, or rock climbing where other bulkier or more expensive cameras

7-1: A point & shoot camera worked fine for this still-life of a sunlit fern and its shadow. (80mm lens)

may be impractical. For convenience, portability and spontaneity in outdoor photography, point & shoots are an excellent choice. Some professional nature photographers — outfitted with top-of-the-line SLRs and an assortment of expensive lenses — also carry point & shoot cameras in their camera bags for special situations where a point & shoot is the best choice.

If you are purchasing a point & shoot camera to take nature photographs, generally you will need to pay more than $100 to get a camera that is sufficiently sophisticated to handle a variety of out-door situations. Many of the better point & shoot cameras are in the $175-$250 price range. As with photo gear in general, you typically get what you pay for.

Some useful features to look for in a point & shoot are: a large, bright viewfinder; a wide zoom range (at least 38-90mm); a minimum focusing distance of less than 3 feet (the shorter, the better); spot metering; weatherproofing; an infinity-lock feature; and backlight compensation — or, better yet, manual exposure compensation.

Alternatives to 35mm Cameras

Advanced Photo System

The newest film format is the **Advanced Photo System** (APS), a smaller film format than 35mm. It was introduced in the 1990s by the major camera and film makers. As you take each exposure, an APS camera allows you to choose between three different print-size options: a classic (C) format with the same ratio (3:2) of length to width as 35mm film; a panoramic (P) format that is three times as long as it is wide; and an HDTV (H) format that is intermediate between the other two. When APS film is processed, in addition to the individual photos, you receive an index print that shows thumbnail-sized versions of all the photos on the roll of film. This makes it easy to choose photos for reprinting.

Most APS cameras are compact point & shoot models that auto-focus and automatically set exposures, though some APS SLRs with a variety of interchangeable lenses are now on the market. A disadvantage of APS cameras at present is that film and processing costs are higher than for 35mm cameras. APS cameras can only use APS film, and 35mm cameras cannot use APS film.

Medium-Format and Large-Format Cameras

A number of film formats larger than 35mm are used by professional nature photographers. These formats fall into two basic categories:

1. **Medium-format** cameras generally use 120 or 220 roll film to produce negatives or slides with a variety of sizes including 6x4.5cm, 6x6cm, 6x7cm, and 6x9cm. By comparison, a 6x7cm negative or slide is more than four times the area of a 35mm negative or slide.

2. Large-format cameras use individual sheets of film, typically 4x5 inches or 8x10 inches in size.

An advantage of medium- and large-format cameras is that they produce much larger negatives and slides than 35mm cameras (see photo 7-2). These larger originals mean that less enlargement of the original is needed to produce prints of a given size. The more that an original negative or slide is enlarged, the more it will lose its apparent sharpness. This means, for instance, that a poster-sized print made from a large-format negative will be significantly sharper than a print of the same size made from an almost identical 35mm negative.

7-2: Medium- and large-format cameras are favored by some photographers because of the fine detail and sharpness of the images. This skunk cabbage leaf was photographed with a 6x7 medium-format camera with a 135mm macro lens.

Medium- and large-format cameras have several distinct disadvantages for the nature photographer:

1. Cameras, lenses, film and processing are all substantially more expensive than with 35mm photography.

2. Most of these cameras lack many of the advanced electronic features — such as autoexposure, autofocus, and built-in motor drives to advance the film — now standard on 35mm SLRs and even on point & shoots.

3. These cameras are considerably heavier and far more cumbersome in the field than 35mm cameras. If you lug around a medium-format camera for several days in the field, a 35mm SLR will seem like a compact point & shoot camera by comparison! But this is not

"Most of these cameras lack many of the advanced electronic features... "

all bad; some professional nature photographers find that the pronounced awkwardness of a medium- or large-format camera forces them to slow down in the field, observe landscapes and wildlife more closely, and compose their photos far more deliberately.

Digital Imaging

The technological wave of the future in photography is digital imaging. Digital cameras store images on an electronic recording medium such as a floppy disk rather than on film.

Using digital imaging software, the images from a digital camera can be transferred to a PC and manipulated, printed, e-mailed to others, or posted on the Internet.

Within the next decade, a significant shift will likely occur from conventional cameras that use film to digital cameras. At present, the vast majority of nature photography is still done with conventional 35mm cameras.

Desirable Camera Features

Exposure Modes

In terms of versatility and ease of operation, the ideal camera is one that allows you to set exposures manually, use semi-automatic exposure settings or use totally automatic exposures. Most point & shoot cameras and a few beginner's SLRs only operate in a totally automatic exposure mode, often referred to as "program" mode ("P" setting on most cameras).

Many SLRs also offer one, two or all three of the following exposure modes:

1. Shutter-priority mode ("Tv" or "S" on many cameras): You set the shutter speed; the camera chooses an appropriate aperture (see photo 7-3).

7-3: This is an example of a photographic situation where choice of shutter speed is important, so shutter priority exposure is useful. Setting a shutter speed of 1/125 sec. ensured a sharp image of the main subjects — the two slow-moving sunlit ducks. (28-200mm zoom lens set at 200mm)

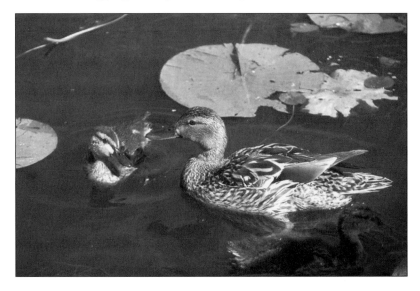

2. Aperture-priority mode ("Av" or "A" on many cameras): You set the aperture (f-stop); the camera then chooses an appropriate shutter speed. This is a popular mode with nature photographers, because choice of aperture — and thus control of depth of field — is often your top priority in setting the exposure.

3. Manual mode ("M" on most cameras): You set both the aperture and shutter speed. This mode maximizes your control over each exposure. A few SLRs, mainly low-priced models, offer only a manual mode.

Many cameras today also have other subject-specific program exposure modes; for example, an action program mode that preferentially chooses faster shutter speeds to freeze the motion of moving subjects.

See your camera owner's manual for descriptions of the exposure modes offered by your particular camera.

Depth-of-Field Preview

Depth-of-field preview is among the most desirable camera features for nature photography. When you push the depth-of-field preview button on a camera, you are manually stopping down the lens diaphragm to the aperture at which the lens is set. The result is that you then actually see the same depth of field — the front-to-back zone of sharpness — as your photograph will have. This way you can easily check in advance whether the visual effect is really the way you want it before you take the photo (see photo 7-4). Without this feature your viewfinder always shows you the image the way it would appear with your lens wide open — that is, at the largest lens aperture and with the least depth of field. In nature photography, depth-of-field preview is invaluable in helping you choose the ideal aperture for each of your photos, especially when you are doing close-ups or medium-range nature portraits.

Depth-of-field preview is not available on point & shoot cameras, and is available on far less than half of the SLRs on the market today. If you would like to become an accomplished nature photographer, strongly consider getting an SLR with depth-of-field preview.

Exposure Compensation

Many point & shoot cameras have some form of exposure compensation feature. Such a feature allows you to manually alter the exposure to compensate for certain types of lighting conditions. On a point & shoot camera, this is frequently in the form of a backlight compensation feature. You typically activate this backlight compensation feature when your main point of interest in the photo is strongly backlit, resulting in your subject appearing dark against a lighter background. Using this feature will cause the camera to substantially increase the amount of light that your film is exposed

"Depth-of-field preview is among the most desirable camera features..."

7-4: Depth-of-field preview allows you to see the front-to-back zone of sharpness in your viewfinder prior to taking a photo. In this close-up of a sun-dappled Great Smoky Mountain stream, depth of field was maximized by stopping down the lens. (exposure: 4 sec. at f/32 with 28-200mm lens set at 135mm)

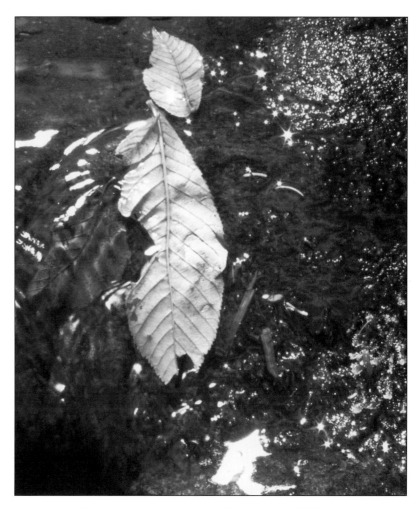

to, thus brightening up your backlit subject. SLRs with manual exposure control will allow you to alter an exposure by manually altering the shutter speed or aperture, or by setting a mechanical or electronic exposure compensation dial.

Built-in Flash

Many SLRs and virtually all point & shoot cameras today have built-in electronic flash units. These units are not particularly powerful — no, you can't light up the Grand Canyon for the perfect landscape photo at sunset. But you can improve many of your nature photos through judicious use of the camera's automatic flash. In particular, use of fill-in flash is becoming increasingly popular to augment available outdoor light for daytime nature photography of subjects close to you. Check your camera owner's manual to determine the effective working distance of your built-in flash and to understand the various flash modes programmed into your camera.

If you have an SLR without a built-in flash, you may find it useful to purchase a separate flash unit if you want to do a lot of wildflower photography. Important points to consider when selecting a flash are the flash's degree of electronic compatibility

with your camera (for ease of use, look for a "dedicated" flash that is made specifically to work with your SLR), the flash's power (expressed as a Guide Number), and the flash's versatility in terms of both automatic and manual features.

Lenses

Your photos are only as good as your lenses. Using the most expensive camera coupled with a cheap lens is like listening to music on a great stereo amplifier that has $10 speakers attached. Simply put, it doesn't work very well. Always use the best lenses you can; in nature photography, there is no substitute for high-quality lenses.

Lens Choices for SLRs

There are literally hundreds of lenses on the market for use with 35mm SLR cameras. A lens is identified principally by its focal length expressed in millimeters (one inch equals 25.4mm). In 35mm camera terminology, a lens with a focal length of approximately 50mm (about 2 inches) is considered a standard lens. Any lens with a focal length significantly less than 50mm is a wide-angle lens (for example, a 24mm, 28mm or 35mm lens). Wide-angle lenses literally show you a wider angle of view; the shorter the focal length, the wider the angle of view (see photo 7-5). Any lens with a focal length significantly more than 50mm is a telephoto lens (for

7-5: Composing nature photos with a wide-angle lens is fun because of the broad angle of view. This West Virginia dogwood in full bloom was photographed looking upward with a 28mm lens.

7-6 and 7-7: Zoom lenses allow you to frame a scene in vastly different ways. These photos of a Great Smoky Mountain landscape were taken from the same vantage point with a 28-200mm zoom lens. The top photo was taken at 28mm focal length. The bottom photo was taken at 100mm. (both exposures: 1/90 sec. at f/11)

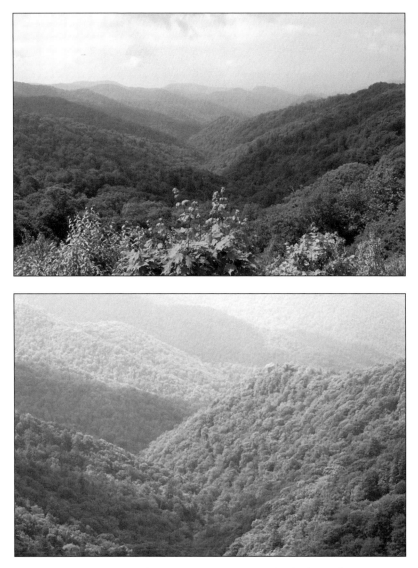

example, a 90mm, 135mm or 300mm lens). Telephoto lenses magnify the subjects you view; the longer the focal length, the greater the magnification of the scene.

For nature photography, zoom lenses are particularly useful. A zoom lens covers a range of focal lengths, and thus allows you to frame a scene in a variety of different ways (see photos 7-6 and 7-7). For instance, a 28-70mm zoom lens extends from a moderate wide-angle focal length (28mm) to a short telephoto focal length (70mm). A 70-300mm lens extends from a short telephoto focal length (70mm) to a moderately long telephoto focal length (300mm) suitable for a lot of good wildlife photography.

Zoom lenses maximize convenience; the combined range of focal lengths of the two zoom lenses mentioned above will cover more than 90% of the needs of most nature photographers in the field. If you like to photograph a lot of expansive landscapes or skies, you may want to get an extreme wide-angle lens such as a 17mm or 20mm lens (see photo 7-8).

7-8: A 17mm lens provided an extremely wide angle view for this image of evergreens and sky in Idaho's Sawtooth Mountains. Note how the image was composed with the sun partially blocked by a tree to prevent the bright sunlight from overpowering the photo.

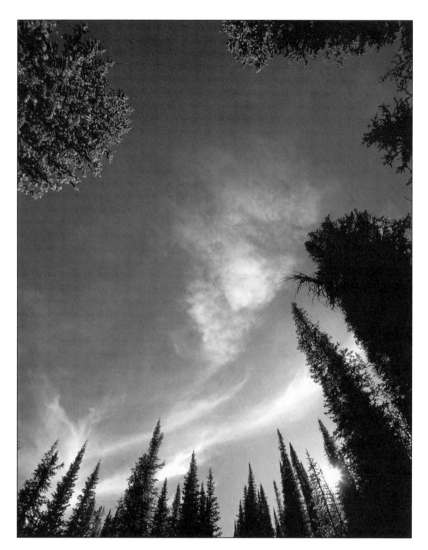

If you love to photograph birds or other small animals, then a very long telephoto lens of 400mm or more will expand your capabilities. Be aware that long telephoto lenses are expensive to purchase and heavy to carry!

When selecting a lens, an important factor to consider in addition to focal length is **lens speed**. This term refers to the largest aperture (the lowest f-stop) of a lens. Each lens is identified by both its focal length and its lens speed. For example, a 300mm $f/2.8$ lens has a maximum aperture of $f/2.8$ and is said to be one stop "faster" than a 300mm $f/4$ lens, and two stops faster than a 300mm $f/5.6$ lens. In other words, the 300mm $f/2.8$ lens has twice the light-gathering ability of a 300mm $f/4$ lens, and thus can be used effectively in lower light conditions. The value of fast telephoto lenses really becomes evident when you are photographing wildlife in low light around sunrise and sunset. Most zoom lenses available today have a largest aperture between $f/3.5$ and $f/5.6$; faster lenses are available, but are usually considerably more expensive.

Teleconverters — supplementary lenses that you place between your camera and a telephoto lens — are useful for

Quick Tips

Teleconverters increase the effective focal length of the lens you are using. For example, a 2X teleconverter doubles the focal length.

7-9: A 2X teleconverter attached to a 180mm f/2.8 lens provided an effective focal length of 360mm for this juxtaposition of gulls and a harbor seal on a northern California beach. Long telephoto lenses visually compress distances, making the seal appear much closer to the gulls than in reality.

wildlife photography. Teleconverters increase the effective focal length of the telephoto lens you are using; a 1.4X teleconverter increases the focal length by 40%, and a 2X teleconverter doubles the focal length (see photo 7-9). Teleconverters have two notable drawbacks: (1) They may noticeably degrade image quality, though in many cases you can still produce excellent images; and (2) they significantly reduce your lens speed. A 1.4X teleconverter reduces lens speed by one stop, a 2X teleconverter costs you two stops of lens speed. Thus a 300mm $f/4$ lens with a 2X teleconverter attached becomes a glacially slow 600mm $f/8$ lens.

Lens Choices for Point & Shoot Cameras

As noted earlier, point & shoot cameras do not have interchangeable lenses; the lens is permanently built into the camera.

In terms of lenses, today's point & shoot cameras come in three main varieties:

1. Wide-angle lens: cameras with a fixed wide-angle lens, usually with a focal length between 28mm and 35mm; good for expansive landscapes.

2. Standard zoom lens: cameras with a wide-angle-to-short-telephoto zoom lens, usually 35-70mm or thereabouts; good for landscapes and nature portraits.

3. Extended-range zoom lens: cameras with a wide-angle-to-medium telephoto zoom lens; popular combinations include 38-105mm, 38-115mm, and 38-140mm. The longer focal lengths, beyond 100mm, increase your "reach" for photographing wildlife. Unfortunately, the lens speed of these extended zoom lenses is very slow when used at the longest focal lengths, which makes it preferable to use medium-to-high-speed films (ISO 200 or ISO 400) if you are going to do much wildlife photography with them.

Filters

Nature photographers sometimes use **filters** to enhance photographs. These supplementary lens attachments are either screwed onto the front of a lens or mounted in a bracket attached to the lens. Filters can be used on virtually any SLR lens, but they are rarely made for use on point & shoot cameras. Of the dozens of filters available, only a handful get widespread use in nature photography with color film. These popular filters are described below. Recalling the admonition earlier in this chapter that your photos are only as good as your lenses, keep in mind that your photos are also only as good as your filters. Buy the best filters you can.

Ultraviolet, Haze and Skylight Filters

Ultraviolet (UV), haze and skylight filters have very little effect on the quality of color photographs. They are principally used by nature photographers to protect the front of the lens from scratches in the field. Some photographers always keep one of these three types of filters on the front of each lens to avoid any potential damage to the lens.

Using one of these filters is a particularly good idea if you plan to walk through heavy brush, scramble over boulders, or photograph near waterfalls or in coastal areas with salt spray.

Polarizing Filters

The polarizing filter or polarizer is an extremely popular filter for outdoor photography. Polarizing filters have several significant functions in outdoor photography:

1. Polarizers can remove reflections from shiny surfaces such as a pond or lake.

2. Polarizers can deepen the blue of the sky and increase the contrast between sky and clouds.

3. Polarizers can increase the overall color intensity in a scene.

When you put a polarizer on your lens, you can rotate the filter in its mount until you see the desired effect through your

"Filters can be used on virtually any SLR lens, but are rarely made for use on point & shoot cameras."

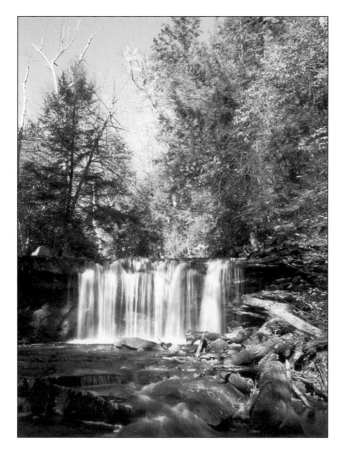

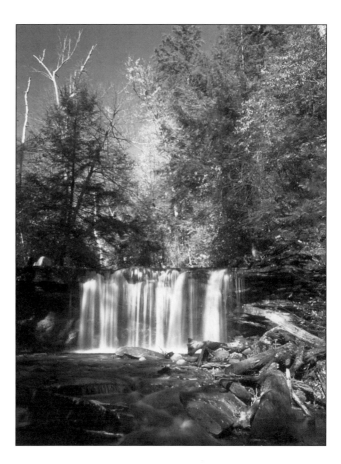

7-10 and 7-11: The photo on the left was made without a filter, the photo on the right was made with a polarizer. In the image to the right, note the deeper sky tone and the reduced reflections in the stream. (exposure: 1/4 sec. and 0.7 sec. at f/22 with a 28-200mm zoom lens set at 28mm)

viewfinder. Thus you can selectively reduce reflections on water, deepen sky colors, or increase color intensity in your scene (see photos 7-10 and 7-11).

A polarizer will have greatest effect on the sky when the sun is at your side — that is, at a right angle to the direction you are pointing your camera — and will have minimal effect when the sun is directly in front of you or directly in back of you, or when the sky is thickly overcast. The reflection-cutting effect of a polarizer is maximized when your camera's line of sight is at a 35-degree angle to the reflective surface, such as the surface of a lake.

Many photographers like the visual effects of a polarizer, possibly because this filter sometimes makes a scene look similar to the way it appears when you are wearing sunglasses. Use a polarizer judiciously, and be aware that a polarizer can sometimes deepen sky colors so much and remove reflections so completely that a natural scene is transformed into a very surreal-looking photograph. If you have an autofocus SLR, you probably need a special type of polarizer known as a circular polarizer — see your camera owner's manual to verify this point.

Warming Filters

The vast majority of nature photography is done without colored filters, but there is one colored filter, a **warming filter**, that many nature photographers use. Warming filters — usually given

the technical designation 81A (weakest tint), 81B (moderate tint), and 81C (strongest tint) — have an amber cast that gives photos a warmer look. These filters are used mainly on cloudy days when the landscape is dominated by grays, greens, and/or blues.

Tripods

As previously emphasized, a tripod — a portable, three-legged stand that supports your camera — is an important accessory for nature photography (see photo 7-12). Fortunately, nearly all cameras today —yes, even point & shoot cameras — have a tripod socket on bottom. And a basic tripod (about $40 and three pounds in weight) is surprisingly inexpensive and lightweight. If you are tripod shopping, consider the following five factors:

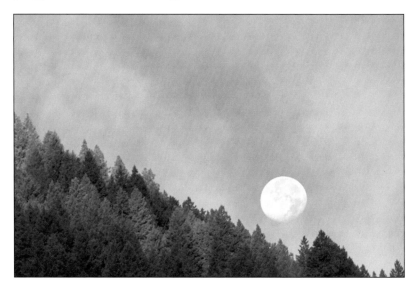

7-12: A sturdy tripod made this photo of the full moon possible. A tripod is indispensible when you photograph with telephoto lenses and slow film in low light. (exposure: 1/30 sec. at f/8 with 180mm lens and 2X teleconverter)

1. Make sure the tripod is <u>heavy enough</u> to support your camera and your largest lens in a stable fashion even on uneven terrain in a stiff breeze.

2. Now that you have made sure the tripod is heavy enough, make sure it is <u>light enough</u> to carry on your photo excursions. A 10-pound tripod is too heavy for most people to comfortably enjoy carrying.

3. Check <u>how low</u> to the ground the tripod will allow you to get; this is very important for close-up photography of wildflowers.

4. Check <u>how easy</u> it is to adjust the tripod head — the part the camera attaches to — and to aim the camera in different directions at different angles.

5. Check to see if the tripod head has a <u>quick-release mount</u> that allows you to quickly attach and remove your camera from the tripod.

Quick Tips

Tripods are extremely useful in nature photography and are highly recommended. A basic tripod is relatively inexpensive and lightweight.

When using a tripod, be sure to firmly attach the camera to the tripod and always make sure the tripod is stable before you take a photograph. And always use the camera's **self-timer** or a **cable release** (or the remote release that is available for some cameras) so that you do not shake the camera when photographing.

Camera Battery Tips

Murphy's First Law of Nature Photography states that any time you go into the field in a remote location, if you do not have a spare camera battery with you, your battery will go dead. Always carry an extra camera battery.

When you purchase camera batteries, check their expiration dates. Fortunately, the lithium batteries that are now standard in most of today's cameras have a much longer shelf life than most earlier types of batteries.

Keep in mind that the performance of camera batteries drops significantly at lower temperatures. When you are in the field in subfreezing temperatures, keep the camera close to your body — for example, beneath a parka or sweater — when you are not photographing. This will help keep the batteries warm and functioning.

If your battery appears to die when you are photographing on a cold day, you can often revive it. Simply remove the battery from the camera and warm it in your hand or against your body, which may well be 75° or more warmer than the air temperature.

Camera Care in the Field

Cameras are surprisingly good at absorbing the bumps, bruises and climactic extremes of field photography (see photo 7-13).

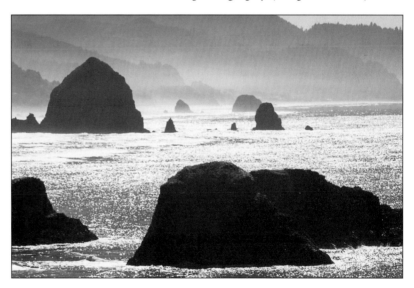

7-13: Coastal areas are great for nature photography. When you photograph on the coast, protect your equipment from salt spray and blowing sand to ensure long life for your camera, lenses and tripod. (75-300mm lens)

As I have learned from personal experience, modern electronic cameras and lenses can even survive unexpected swims in fresh water, if you immediately dry out the equipment as much as possible and deliver it to a good camera repair person.

"... keep your camera covered except when you are actually taking pictures."

A few guidelines are useful in ensuring that your photo equipment has a long and useful life:

1. Keep your equipment as dry as possible. You can certainly photograph in rain or snow, but keep your camera covered except when you are actually taking pictures. When you return from the field, promptly dry your camera, lenses and tripods with a soft towel.

2. In coastal locations, avoid getting sand or salt water in your camera. Tiny grains of sand can wreak havoc with moving parts, and salt spray can lead to rusting of internal components. Never leave your camera uncovered on a beach towel.

3. In the field, in the car and at home, always protect your camera from dust and extreme heat. On a hot, sunny day, your car's dashboard is a terrible place to keep a camera unless you are doing an experiment to determine the melting points of plastics!

Other Field Gear

When going into the field to do nature photography, consider taking along the following items in addition to your camera gear:

- extra film: always carry twice as much as you think you will need

- small foam pad: useful to sit on and kneel on to photograph, as well as for padding equipment and covering camera in rain

- small notebook and pencil to record exposures and field notes

- water repellent jacket and rain pants

- hat and gloves

- spare pair of heavy socks: a great cure for wet feet, and they can also can be used as padded lens cases and as mittens

- food and plenty of water: never drink from streams and lakes

- insect repellent and sunscreen

- topographic trail maps and compass

- if you will be venturing off trails or visiting areas with which you are unfamiliar, a GPS (global positioning system) unit is a real asset and a potential lifesaver

CHAPTER EIGHT

Film

What Film Speed Should You Use?

The sensitivity of photographic film to light is rated on a standard scale known as ISO. A film's ISO rating is referred to as the film speed. This rating typically appears prominently on the film packaging. For example, Kodak Gold 100, has a rating of ISO 100. The higher the ISO rating, the more sensitive the film is to light. For instance, an ISO 200 film is twice as light sensitive as an ISO 100 film, and an ISO 400 film is four times as light sensitive as an ISO 100 film. In practical terms, this means that the ISO 400 film only needs to receive one-fourth as much light as the ISO 100 film to produce a particular exposure.

Medium-Speed Films for General Use

Medium-speed films rated at ISO 100 or ISO 200 are good all-purpose films for most everyday uses. These films are a suitable choice for most natural lighting conditions and most subjects; they

> "A film's ISO rating is referred to as the film speed."

8-1: Medium-speed (ISO 200) film is often appropriate for photographing wildlife, such as this great horned owl sitting on its nest in Oregon. (75-300 zoom set at 300mm)

are widely used for wildlife photography in particular (see photo 8-1 on the previous page). They have good color rendition and pleasing levels of contrast.

Slow Films for Sharpness

Much of the nature photography that appears in magazines, calendars, and coffee-table photo books is produced with slow films that have an ISO rating of less than 100. In particular, Kodachrome 25 and 64 and Fujichrome Velvia (ISO 50) slide films have a loyal following among professional nature photographers (see photo 8-2).

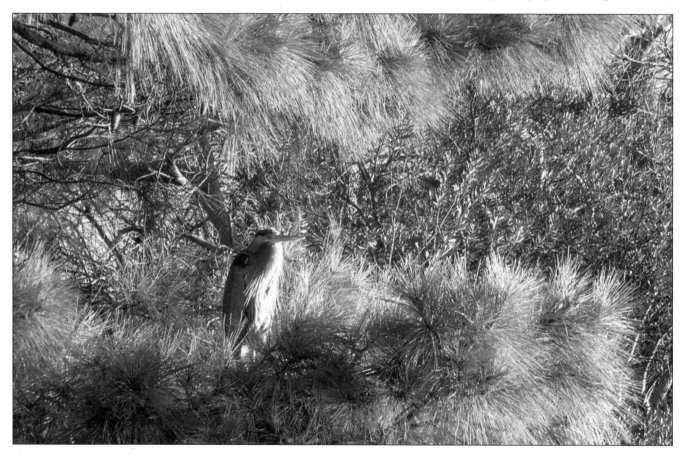

8-2: Very slow slide films produce very sharp photos, with high resolution and no visible graininess. Kodachrome 25 was used to photograph this great blue heron in Virginia's Chincoteague National Wildlife Refuge. (70-210mm zoom lens set at 210mm)

In addition to beautiful color reproduction and pleasing levels of contrast, the advantages of these slow films are that they are extremely fine-grained, very sharp, and can record fine detail. Even when enlarged to 8x12 or beyond, photos taken with these films are impressive for their sharpness and absence of graininess (see photo 8-3). All but a handful of the illustrations in this book were taken with Kodak and Fuji slide films with speeds of ISO 100 or slower; the photo captions identify cases when faster films were used. The black and white photos in this book were converted from color slides for publication.

Of course, part of the challenge of nature photography is that it involves numerous trade-offs and compromises. Slow films have a

8-3: Note the exquisite sharpness of the web of branches in this winter portrait of an Appalachian forest taken with Koda-chrome 25. (70-210mm zoom lens)

significant disadvantage compared to medium-speed films in that they need a lot more light to produce an acceptable exposure. Many excellent nature photo situations are in very low light, for example, in a dense evergreen forest or in a swamp at dusk. If animals are moving in a low-light scene, slow films may not allow for a fast enough shutter speed, and the moving animals will be blurred.

High-Speed Films for Special Situations

At the other end of the film-speed spectrum are high-speed films of ISO 400 and higher, all the way up to ISO 3200. That's fast. The strong point of high-speed films is that they can produce good exposures even in very low light. ISO 400 is an excellent choice when you want to photograph animals in low light situations or if you are taking close-ups of wildflowers that are blowing in the breeze. Whether your camera is automatically selecting exposures or you are manually setting exposures, high-speed films allow for faster shutter speeds to photograph motion without blurring (see photo 8-4). High-speed films are also favored when you

8-4: High speed film — ISO 400 — made it possible to photograph these migrating Canada geese in Oregon flying beneath the moon at dusk. (exposure: 1/60 sec. at f/5.6 with 75-300mm zoom lens)

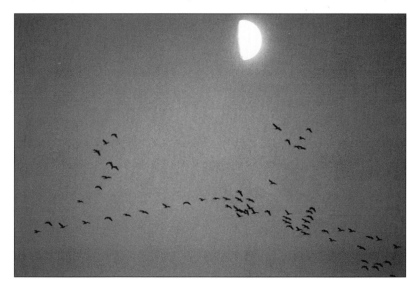

8-5: *High-speed film can be useful even for landscape portraits. The grainy softness of ISO 1000 film is ideal for this peaceful forest scene on a snowy January afternoon in an Appalachian forest with little ambient light. (exposure: 1/60 sec. at f/4 with 90mm lens)*

are literally photographing in the dark (for instance, if you are photographing a comet, a meteor shower, or other astronomical subjects). Since high-speed films allow you to do nature photography in very low light conditions, you may wonder why nature photographers do not use these films all the time. Unfortunately, high-speed films have drawbacks.

In addition to their higher prices, most high-speed films are significantly grainier, less sharp, and less able to reproduce fine detail than slower films. When color photos taken on high-speed films are enlarged to 8x12 or larger, the graininess and loss of sharpness are often obvious.

Of course, some photo subjects — for instance, snow falling in a forest in low light — may actually be enhanced by grainy film (see photo 8-5). Just keep in mind that an ISO 800 film will not give you the same photo as an ISO 100 film, and use high-speed films selectively.

Print Film vs. Slide Film

A basic film choice is whether to use color print film or color slide film. Print film is a negative film — the exposed film is chemically processed at a photo lab to produce negatives that are then printed on photographic paper.

Slide film is a positive film — the exposed film is processed, then cut and placed in slide mounts; there is no negative. Slides are

Quick Tips
Three important factors to take into account when choosing film are cost, photo usage, and exposure latitude.

also referred to as transparencies or chromes. Your choice of which of these types of film to use may depend on the following factors:

1. Cost: The cost of film and processing vary greatly depending on where you buy your film and where you get it processed. In many cases, you will find that print film is much less expensive to buy but that processing costs are higher than for slide film. If cost is a major factor for you, compare the film and processing prices in your location.

2. Usage: What do you like to do with your nature photos? Many people simply enjoy having prints to show to family and friends, and to put into albums. You can also get color slides made into prints, but the cost of doing this with all your favorite photos is prohibitive. If you want to use your photography for teaching or publication, then slides are often the preferred medium. If you plan to amass a large collection of hundreds of photos of plants or animals or natural habitats, then slides may be the best choice, because of the ease of labeling, filing and subsequently using them.

3. **Exposure latitude**: Color print films have much wider exposure latitude than color slide films. This means that the camera's (or the photographer's) choice of exposure must be much more precise to produce an acceptably exposed photo with slide film than with print film. Compared to slide film, color print film is much more forgiving of exposure errors. This is partly because of the chemistry of the film itself, and partly because errors in exposure on print film are corrected to some degree when the negatives are printed at your local photo lab. In practice, you can overexpose or underexpose your print film by as much as two stops relative to the optimal exposure and still frequently get an acceptable photo. If you use a point & shoot camera, or if you use an automatic SLR camera and do not manually set exposures, then you can expect to get a significantly higher percentage of acceptable exposures by using color print film for nature photography.

The vast majority of amateur photographers use color print film, whereas the vast majority of professional nature photographers use color slide film. Many professional nature photographers like the sharpness and vivid colors of slow slide films for optimal image quality, but their choice of slide film also has a lot to do with how they use their images in publishing projects and in slide presentations (see photo 8-6).

> "If cost is a major factor for you, compare the film and processing prices in your location."

8-6: This photo of autumn foliage was taken with Fujichrome Velvia, an ISO 50 slide film. It demonstrates the extraordinarily fine detail that attracts many nature photographers to slide film. (exposure: 1/60 sec. at f/4 with 90mm lens)

In terms of film speed, one significant difference between color print and color slide films is that ISO 200 and 400 color print films are surprisingly comparable in quality to ISO 100 color print films — the ISO 200 and 400 color print films generally aren't quite as sharp or grain-free, but they are very close! On the other hand, ISO 200 and 400 color slide films are noticeably grainier and less sharp than slower slide films. In daylight, professional nature photographers usually do not use ISO 200 or faster slide films except when they absolutely need the additional film speed to allow them to use faster shutter speeds to freeze the motion of moving wildlife.

Which Brand of Film is Best?

Film choices can be confusing — more than 100 different color films are on the market today. This count does not even include the dozens of different store brand films typically made by the major film manufacturers and packaged under the brand name of a discount store, drugstore, supermarket or camera shop.

So what's a beginning nature photographer to do? Is there really one brand of film that is best for you? The answer is that film choice

"...film choice is very subjective and you are the best judge of what film to use."

8-7: In choosing what films are best for your nature photography, consider film speed, sharpness, graininess, color, tone, contrast and exposure latitude. For example, Fujichrome 100 produced pleasing results in this study of stone and water. (exposure: 0.7 sec. at f/22 with 75-300mm zoom lens)

is very subjective and you are the best judge of what film to use (see photo 8-7). If you want to learn more about film, try out four or five varieties — different brands and different speeds — and carefully study your results. The most important thing is to find one or two films that you really like to use in most photographic situations.

Choosing Photo Labs

Unless you live in a very sparsely populated area, you probably have numerous choices of where to get your film processed. Keep in mind that the caliber of processing and printing services plays a key role in determining the quality of your photos: *Good film + excellent exposures + poor photo lab work = lousy photos.*

Choose photo processing services based on consistently good work, customer service, price and reputation, rather than on speed. You will generally pay more for the convenience of rapid film processing. If a photo lab repeatedly makes mistakes or does not take responsibility for its work, then do not hesitate to take you business elsewhere. There are plenty of good photo labs out there.

Beyond the Basics

Learning from Your Mistakes — and Your Successes

Taking Good Field Notes

To learn as much as you can from your nature photographic experiences, it is useful to take detailed notes while you are in the field. Second only to a tripod, your most useful accessories in the field may well be a small notebook and a pencil. Some nature photographers prefer to carry a miniature cassette recorder, finding it easier to record their notes orally rather than writing them down. What should you write down in your field notebook? It is helpful to note the date, time, lighting conditions, the geographic location, the type of film you are shooting, and the photo equipment you are using. For each exposure, you may want to record the following:

- the frame number

- a brief description of the subject matter (for example, "white oak leaves and acorns in Elk Creek")

- the lens used — if you have a zoom lens, record the focal length at which the photo was taken (for example, "28-70mm zoom set at 50mm")

- if you are using an SLR camera, the shutter speed and aperture

- exposure compensation, if any (for example, "+1," means purposely overexposed by one stop compared to the metered exposure)

- filters used, if any

Opposite page: In challenging exposure conditions, such as this sunrise, write down what you do in the field, then review your notes as you evaluate your photos. In this case, purposeful overexposure of one stop produced a pleasing image. (exposure: 0.7 sec. at f/32 with 28-200mm zoom lens set at 28mm)

The more detailed your notes, the more valuable they will be to you when you are evaluating your photos later on. Another trick to augment your note taking is to photograph interpretive signs featuring trail maps and descriptions of flora and fauna; such signs are often present at trail heads on public lands or in private nature preserves. Photographs of these signs are handy for later identification of locations and subjects in your photographs.

You may also want to combine your photo note taking with a personal nature journal in which you record the flora and fauna present, make observations about animal behavior, note sites where uncommon wildflowers are growing, and make other notes about seasonal changes and the condition of the ecosystems you visit. If you enjoy drawing, then small sketches of plants, animals and their habitats are a useful addition to your field notes and photos.

Critiquing Your Photos

Sometimes professional nature photographers jokingly say that the biggest difference between amateurs and professionals is that the pros take far more bad photographs.

This is because professional nature photographers take a huge number of photos compared to the typical person who takes nature photos for fun.

In reality, the pros make their share of photographic mistakes, but they carefully evaluate their photographic failures to increase the odds of success next time they go into the field. No one can make every nature photo turns out perfectly, especially given the challenging subject matter and continuously changing lighting conditions in natural environments.

The key is to learn as much as you can from your bad photos and from your good ones, so that your rate of photographic success and your confidence will increase each time you pick up your camera (see photo 9-1).

9-1: When trying a new technique, take notes so that you can learn from your experience. This abstract close-up of sunlight sparkling on a Hudson Valley brook was purposefully overexposed by one stop. (exposure: 0.7 sec. at f/27 with 75-300mm zoom lens set at 300mm and +3 supplementary close-up lens)

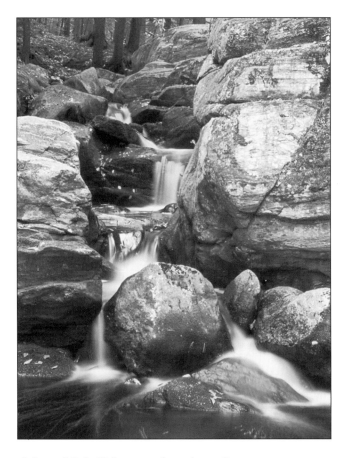 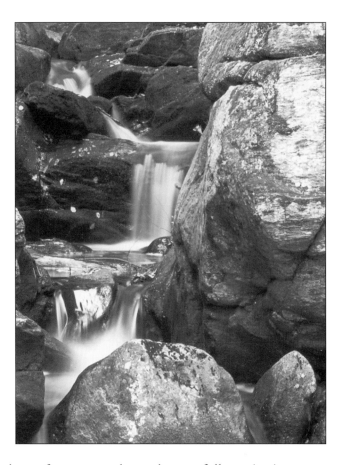

9-2 and 9-3: Take several versions of a scene, record your camera settings, then compare the results. These photos of a Connecticut stream were taken from the same vantage point. The lens was zoomed from 65mm in the photo on the left to 105mm in the photo on the right. (both exposures: 6 sec. at f/27 with 28-200mm zoom lens)

You can learn from your photos by carefully reviewing your results each time you have a roll of film processed. Spread out your prints on a well-lit table, or arrange your slides on a light box, and compare the results with your field notes (see photos 9-2 and 9-3). If you manually set exposures, pay particular attention to situations in which you took more than one photo of the same scene and bracketed your exposures. Evaluate each photo based on the following four criteria:

1. Is the subject sharply focused?

2. Is the photo aesthetically pleasing?

3. Is the image well composed?

4. Is the photo well exposed?

An easy way to keep these criteria in mind is by remembering the first letter of each criterion: **F** for focus, **A** for aesthetics, **C** for composition, and **E** for exposure = **F.A.C.E.**

With a little practice, this acronym for evaluating your photos will become second nature to you. Better yet, be proactive and use this acronym as a mental checklist in the field just before taking each photo.

CHAPTER TEN

Sharing Your Nature Photography

Nature Photo Contests

Hundreds of photo contests offer opportunities for amateur nature photographers. Some of the best known annual contests are sponsored by national or regional environmental, wildlife, photographic, and travel magazines. One of the exciting parts of these contests is that in many cases the winning photos are published in the magazines (see photo 10-1).

For details, watch for contest entry information in your favorite magazines. Other nature and wildlife photo contests at the local or regional level are sponsored by newspapers, camera clubs, parks, nature centers, and schools. Check with your local camera clubs, art associations and parks departments for details.

10-1: Many outdoor magazines sponsor photo contests that give nature photo enthusiasts an opportunity to get their winning photos published. Furry animals such as this Virginia white-tailed deer are a perennial contest favorite. (70-210mm zoom lens)

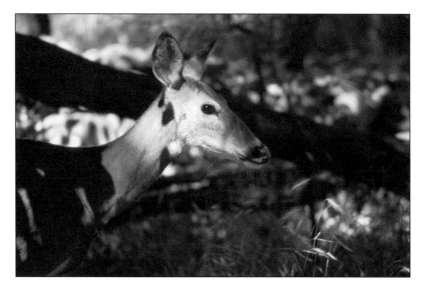

If you consider entering contests, be aware that all contests are not the same. Some contests ask for exorbitant entry fees, while others are free. Some contests will not return your photos when the contest is over. Some require you to turn over all photo rights to the contest sponsor for potential advertising use. Read contest rules carefully before entering. It also pays to review previous winning photos in any contest you plan to enter; different contests emphasize different types of photography. For instance, some contests look for exotic destinations, some seek photos of unusual or rare flora and fauna, and others primarily emphasize creativity.

Nature Photo Exhibits

Group nature photo exhibits, sometimes in conjunction with photo contests, are frequently sponsored by parks, nature centers, camera clubs, county and state fairs, art associations, and environmental organizations. These exhibits, usually either free or requiring a small entry fee, give you a chance to publicly display your best photos. If you create a large collection of truly exceptional photos, you may want to approach local galleries and art spaces — in restaurants, banks, schools and corporate offices — to display your work in a one-person show.

Putting Your Photos on the Internet

Opportunities are rapidly multiplying for posting your nature photos on the Internet, where the world is your audience. Many photo labs will now put your photos in a digital format on a Photo CD or floppy disk, or will post them directly on the World Wide Web for your access. Nature photo enthusiasts around the world are using their images to enhance personal, family, school and business Web sites. You can get a plethora of ideas for displaying your photos by surfing through some of the thousands of photo sites on the Web, including sites maintained by many top professional nature photographers.

Nature Photo Slide Programs

A great way to share your nature photography and get wider attention for your photos is to assemble and present nature photo slide shows in your community.

If this interests you, consider all the outlets in your community that may provide a receptive audience for your nature photos, such as school classes and assemblies, garden clubs, grassroots environmental organizations, nature centers, local parks, travel clubs, senior centers, and camera clubs. Audiovisual companies can also transfer your slides to video for presentation.

"...you may want to approach local galleries and art spaces..."

If photographs, like words, are to speak with power, they must flow from the heart.
— David Cavagnaro

Epilogue

Nature Photo Ethics

Nature photography can be a great joy. Photographing in the field involves a certain closeness with the natural world that many people rarely experience in today's fast-moving society.

Photographing nature is an opportunity to slow down and immerse yourself in the astonishingly diverse, vibrant world of the plants and animals that inhabit the earth's ecosystems. We truly live in a world of infinite wonders.

As a nature photographer, consider the impact you have on the voiceless creatures that you encounter in the wild. Always put safety first: the personal safety of you and your photographic companions as well as the safety and well-being of the animals you photograph. Never put undo stress on wildlife for the sake of getting a photograph. A wild animal faces enough natural stresses in life: predators, extremes of weather, periodic food shortages, disease and parasites.

In national parks, it is sad to see camera-toting tourists jumping out of their cars to awkwardly chase deer and elk through meadows for the sake of a photograph. Try to use your patience and your knowledge of wildlife to create great wildlife photos and memorable photo experiences without disturbing or harming your photo subjects.

While out in the field photographing, set a good example for other nature photographers and recreational users of public lands. Also respect private property rights. Many landowners are willing to allow you to photograph on their land if you ask permission beforehand.

Wherever your photographic rambles take you, strive to leave nothing more than footprints to mark your forays into the wild places. And keep in mind that in some cases even footprints can significantly alter an environment.

Avoid disturbing fragile habitats such as coastal tide pools, trackless tundra or steep, easily erodible stream banks. In a single morning, a handful of well-meaning nature photographers can cause drastic, lasting damage to a tide pool, a bog or an alpine meadow by

"Never put undo stress on wildlife for the sake of getting a photograph."

Epilogue: When you venture into natural areas to photograph, leave only minimal traces of your passing. Thus, you will help ensure good photo opportunities for those who follow. (50mm lens)

clumsy placement of feet and tripods. Make it a point to leave each site you photograph in the same condition you found it.

One more thing: Share your nature photography. Use your nature photographs to brighten the lives of others and to inspire a sense of wonder and compassion for the life around us!

Appendix

"Learn everything you can about the plants, animals and habitats ..."

Ten Tips for Great Nature Photos

1. Take your time and move slowly in the field. The quality of your nature photos directly depends on the amount of time you spend in the field.

2. Know your subjects. Learn everything you can about the plants, animals and habitats that you like to photograph.

3. Simplify your photo compositions. Strive for clear, strong messages in your images.

4. Go out in the field early and stay out late. Use that great early morning and late evening light.

5. Experience is the best teacher, so take field notes, then carefully review your photos. Get feedback from others who enjoy photography as much as you do.

6. Photograph as much as you can in your own backyard. Become the best nature photographer you can in your local parks and natural areas. You will likely get your best photos in the places you know and love best.

7. Learn as much as you can about the capabilities of your camera, lenses and film. Experiment.

8. Use a tripod. It is your most valuable photo accessory.

9. Try something new; break the "rules" of photography. Be creative!

10. Be patient as you learn nature photography, and have fun while you are out in the field! With time and practice you will develop confidence in your photographic skills.

Nature Photo Troubleshooting: FAQs

If you are having trouble shooting good nature photographs, consider the following commonly asked questions about equipment and techniques.

Question: What do you do if your camera has frozen up and will not take pictures?

Answer: Turn off the camera, remove the battery, wipe the battery off with a soft cloth, then put it back in the camera. This frequently solves the problem. If not, then try a new battery.

Question: What if most of your pictures are blurred?

Answer: Make sure you are standing still and holding the camera still when you photograph. It usually works well to prop the camera against your face, and let your elbows rest easily against your body. Thus, your two arms and your head form a human tripod to stabilize your camera. It may also help to take a deep breath and exhale, then push the shutter release. Some photographers hold their breath and tense up while preparing to take a photo, to the point that they are trembling as they take the picture.

If you are using a tripod, be sure that all three tripod legs are in stable positions, that all the fittings on the tripod are tight, and that the camera is securely attached to the tripod.

Question: What if your photos consistently come out poorly?

Answer: If you get color prints that have a strong color bias—say, everything has a pink tinge to it — ask the photo lab to reprint them at no charge. If the lab refuses, find another place to get your photo processing done! A consistent color bias may simply be the result of poor operation of the photo lab's printing machine. In many cases, your negatives are fine and can be properly printed to produce good photos. If your photos are consistently underexposed (too dark) or overexposed (too light), then review your camera owner's manual to make sure you are operating your camera properly.

Two common culprits that produce consistently bad exposures are 1) an exposure compensation feature is accidentally turned on for an entire roll of film, or 2) the film speed is not set correctly on an older camera on which you must manually set the film speed. If a poor exposure problem persists, have the camera checked over by a camera repair shop.

Question: Do film expiration dates matter?

Answer: Yes, film does age, and over a period of years its color balance will noticeably shift. When buying film, always check the expiration date. If you buy film in quantity and keep it for more than a few months, consider refrigerating the film to slow down the aging process.

Question: What if your wildlife photos are blurred?

Answer: Wildlife photos may not turn out sharply focused for several reasons. Wildlife is frequently photographed in low light.

"It may also help to take a deep breath and exhale ..."

Sometimes the animal is moving and the shutter speed is too slow (1/60 sec., for example) to freeze the motion.

In this case, using faster film such as ISO 200 or 400 may be the best solution. Another common culprit in blurred animal photos is that the camera's autofocus is focusing on something other than the animal, especially if the animal is not in the center of the viewfinder.

Learn from your camera owner's manual what your camera's autofocus actually focuses on. For wildlife photography, you may prefer to manually focus if your camera allows you to do so.

Question: What if your photos are framed differently than what you see through the viewfinder?

Answer: Beginning photographers often complain that their photos appear to be cropped differently than they intended when they took the pictures. For example, the deer's head is "chopped off" in the photo, or the wildflower that seemed perfectly centered in the viewfinder is off to one side in the photo. If this happens to you, the solution is usually simple.

First, if you are using a point & shoot camera, check the owner's manual to find out what the framing lines in your viewfinder indicate. These lines are designed as a guide to show you what your camera actually includes in the image.

Second, make sure that you are looking squarely into the viewfinder and your eye is centered on the viewfinder.

Sources for Nature Photo Information

Magazines

Nature's Best (quarterly), Image Hunter Publishing, PO Box 10070, McLean, VA 22102; phone: 800-772-6575

Nature Photographer (bimonthly), Nature Photographer Publishing Co. Inc., PO Box 690518, Quincy, MA 02269-0518; phone: 617-847-0095

Outdoor and Nature Photography (quarterly), 1042 N. El Camino Real, Suite B-123, Encinitas, CA 92024

Outdoor Photographer (10 issues/year), PO Box 56381, Boulder, CO 80322-6381; phone: 800-283-4410; www.outdoorphotographer.com

Organization

North American Nature Photography Association (NANPA), 10200 West 44th Ave., Suite 304, Wheat Ridge, CO 80033-2840; phone: 303-422-8527; www.nanpa.org

"... you may prefer to manually focus ..."

Glossary

Advanced Photo System (APS): A new film format that is smaller than 35mm. APS cameras and film allow you to take photos in three different picture formats: classic, panoramic and HDTV.

Aperture: The diameter of the lens opening through which light passes to reach the film. Apertures are commonly expressed as f-stops.

Autofocus: An electronic system in most point & shoot and SLR cameras that automatically focuses the lens.

Backlight compensation: A feature on many point & shoot cameras that is used to produce better exposures in situations where a dark or shaded subject is surrounded by a bright background, as when sunlight is shining on the back side of the subject. This feature purposely overexposes the image compared to the exposure meter reading.

Blind: A camouflaged structure that conceals a photographer and makes it possible to unobtrusively observe and photograph wildlife.

Bracketing: The technique of taking two or more exposures of the same scene with slightly different exposure settings. This is usually done by taking an exposure at the metered exposure setting, then taking additional exposures at other settings varying from one another by half or full stops. Bracketing is often used in difficult or unusual exposure situations.

Cable release: A short metal cable that attaches to the camera's shutter release and allows you to trip the shutter release without shaking the camera. A cable release is used when the camera is mounted on a tripod.

Composition: The arrangement of the artistic elements — shape, form, color, tone, pattern, texture, balance and perspective — that make up a photograph.

Depth of field: In a photograph, the range of distances from near to far that appear in acceptably sharp focus. Depth of field depends on the focal length of the lens, the lens aperture (f-stop) and distance at which the lens is focused.

Depth-of-field preview: A feature on some SLRs that lets you view a scene's actual front-to-back zone of sharpness given a particular aperture setting.

Exposure: The amount of light that reaches the film. Exposure is determined by the duration and intensity of light striking the film; these two variables are controlled by the shutter speed and aperture respectively.

Exposure latitude: A measure of a film's ability to produce acceptable photos when it is underexposed or overexposed. Color print films generally have much greater exposure latitude than slide films.

Exposure meter: A light-measuring device built into your camera that determines how much light is reflected from the subject and thus how to expose the image. Also known as "light meter" or simply "meter." As a verb, metering refers to pointing your camera toward a subject to measure or read how much light is reflected from it.

Extension tube: A hollow metal or plastic cylinder that is mounted between the camera and lens to reduce the minimum focusing distance of the lens for close-up photography.

Film speed: A measure of film's sensitivity to light. Film speed is rated on a standard scale known as ISO; for example, an ISO 200 film is twice as light sensitive as an ISO 100 film.

Filter: A supplementary lens attachment that is mounted or screwed onto the front of a lens or mounted on a bracket attached to the lens to enhance photographic images.

Focal length: The distance from the optical center of a lens to the film, measured in millimeters; this is the usual way of identifying lenses.

Focus lock: A common feature on point & shoot and autofocus SLR cameras; when you push the shutter release down approximately halfway, the camera autofocuses and remains focused until you take your finger off the shutter release. This allows you to focus on your subject, then recompose the photograph before taking the photo.

f**-stop:** The standard way of expressing the lens aperture (the diameter of the lens opening); f-stops include $f/2.8$, $f/4$, $f/5.6$, $f/8$, $f/11$, $f/16$, and $f/22$, where f represents the focal length of the lens. Thus, $f/2.8$ is a comparatively large lens opening; $f/22$ is a comparatively small lens opening.

Large format: A film format larger than 35mm and medium format. Large-format cameras typically use sheets of film that are 4x5 inches or 8x10 inches.

Lens speed: The largest aperture of a particular lens.

Macro lens: A lens designed especially for close-up photography. It can be focused at very short distances from the subject.

Medium format: A film format larger than 35mm, but smaller than large format. Medium-format cameras use 120 or 220 roll film and produce negatives or slides with dimensions such as 6x6 cm and 6x7 cm.

Minimum focusing distance: The shortest camera-to-subject distance at which a particular lens is capable of focusing.

Overexposure: A photo or a portion of a photo that is too light ("washed out") because the film was exposed to too much light.

Polarizing filter: A filter that reduces reflections from shiny surfaces, enhances color saturation, and deepens blue skies.

Rule of thirds: A guideline for photo composition that suggests visualizing your viewfinder divided into thirds, then placing

the main subject(s) of an image near the intersections of these "thirds" lines.

Self-timer: A delayed exposure feature on nearly all cameras; you push the shutter release and 10 seconds (or some other measured time interval) later the camera takes a photo.

Shutter speed: The amount of time that the camera's shutter is open during an exposure to allow light to reach the film. Shutter speeds are typically measured in fractions of a second, such as 1/125 sec. or 1/60 sec.

Slide film: Film that produces positive transparencies, commonly known as slides or chromes, rather than negatives.

SLR camera: A single-lens-reflex (SLR) camera has a viewfinder that allows you to look through the lens. SLRs use interchangeable lenses.

Spot meter: A type of exposure meter, built into some SLRs and point & shoot cameras, that evaluates the reflected lighting of a small area — a "spot" — in the center of the image as seen through the viewfinder.

Stop: The increment between each of the standard shutter speeds and between each of the standard apertures (f-stops). Changing either the shutter speed or the aperture by one stop will either double or cut in half the amount of light that will reach the film during an exposure.

Supplementary close-up lens: A filter-like accessory that screws onto the front of a lens and reduces the minimum focusing distance of the lens, thus allowing the photographer to take photos closer to subjects.

Teleconverter: A specialized lens that you attach between your camera and a telephoto lens to substantially increase the focal length of the telephoto lens.

Telephoto lens: A lens with a focal length significantly longer than 50mm.

Underexposure: A photo or a portion of a photo that is too dark because the film was not exposed to enough light.

Warming filter: A filter that has an amber cast to give photos a warmer look.

Wide-angle lens: A lens with a focal length significantly shorter than 50mm.

Zoom lens: A lens that can be adjusted to a range of different focal lengths.

Index

Other Books from Amherst Media, Inc.

Big Bucks Selling Your Photography

Cliff Hollenbeck

A complete photo business package for all photographers. Includes secrets to starting up a business, getting paid the right price, and creating successful portfolios. Set financial, marketing and creative goals. This book will help to organize business planning, bookkeeping, and taxes. $15.95 list, 6x9, 336p, order no. 1177.

Great Travel Photography

Cliff and Nancy Hollenbeck

Learn how to capture great travel photos from the Travel Photographer of the Year! Includes helpful travel and safety tips, equipment checklists, and much more! Packed full of photo examples from all over the world. $15.95 list, 7x10, 112p, b&w and color photos, index, glossary, appendices, order no. 1494.

Stock Photography

Ulrike Welsh

This book provides an inside look at the business of stock photography. Explore photographic techniques and business methods that will lead to success shooting stock photos — creating both excellent images and business opportunity. $29.95 list, 8½x11, 120p, 58 photos, index, order no. 1634.

Achieving the Ultimate Image

Ernst Wildi

Ernst Wildi shows any photographer how to take world class photos. Features: exposure, metering, the Zone System, composition, evaluating an image, and more! $29.95 list, 8½x11, 128p, 120 b&w and color photos, index, order no. 1628.

Lighting Techniques for Photographers

Norm Kerr

This book teaches you to predict the effects of light in the final image. It covers the interplay of light qualities, as well as color compensation and manipulation of light and shadow. $29.95 list, 8½x11, 120p, 150+ color and b&w photos, index, order no. 1564.

Black & White Portrait Photography

Helen T. Boursier

Make money with b&w portrait photography. Learn from top b&w shooters! Studio and location techniques, with tips on preparing your subjects, selecting settings and wardrobe, lab techniques, and more. $29.95 list, 8½x11, 128p, 130+ photos, index, order no. 1626.

Computer Photography Handbook

Rob Sheppard

Learn to make the most of your photographs using computer technology! From creating images with digital cameras, to scanning prints and negatives, to manipulating images, you'll learn all the basics of digital imaging. $29.95 list, 8½x11, 128p, 150+ photos, index, order no. 1560.

Special Effects Photography Handbook

Elinor Stecker Orel

Create magic on film with special effects! Step-by-step instructions guide you through each effect, using things you probably have around the house. $29.95 list, 8½x11, 112p, 80+ color and b&w photos, index, glossary, order no. 1614.

Infrared Photography Handbook

Laurie White

Covers black and white infrared photography: focus, lenses, film loading, film speed rating, batch testing, paper stocks, and filters. Black & white photos illustrate how IR film reacts. $29.95 list, 8½x11, 104p, 50 b&w photos, charts & diagrams, order no. 1419.

Wedding Photographer's Handbook

Robert and Sheila Hurth

The complete step-by-step guide to succeeding in the exciting and profitable world of wedding photography. Shooting tips, equipment lists, must-get photo lists, business strategies, and much more! $24.95 list, 8½x11, 176p, index, b&w and color photos, diagrams, order no. 1485.

The Art of Infrared Photography / 4ᵗʰ Edition

Joe Paduano

A practical, comprehensive guide to infrared photography. Tells what to expect and how to control results. Includes: anticipating effects, color infrared, digital infrared, using filters, focusing, developing, printing, handcoloring, toning, and more! $29.95 list, 8½x11, 112p, order no. 1052.

Professional Secrets for Photographing Children

Douglas Allen Box

Covers every aspect of photographing children on location and in the studio. Prepare children and parents for the shoot, capture a child's personality, and shoot story book themes. $29.95 list, 8½x11, 128p, 74 photos, index, order no. 1635.

How to Operate a Successful Photo Portrait Studio

John Giolas

Combines photographic techniques with practical business information to create a complete guide book for anyone interested in developing a portrait photography business. $29.95 list, 8½x11, 120p, 120 photos, index, order no. 1579.

Profitable Portrait Photography

Roger Berg

Learn to profit in the portrait photography business! Improve studio methods, lighting techniques and posing to get the best shot in the least time. $29.95 list, 8½x11, 104p, 120+ b&w and color photos, index, order no. 1570.

Family Portrait Photography

Helen T. Boursier

Tells how to operate a successful family portrait studio, including marketing family portraits, advertising, working with clients, posing, lighting, and selection of equipment. $29.95 list, 8½x11, 120p, 123 photos, index, order no. 1629.

Telephoto Lens Photography

Rob Sheppard

A complete guide for telephoto lenses! This book shows you how to take great wildlife photos, portraits, sports and action shots, travel pics, and much more! Over 100 photographic examples. $17.95 list, 8½x11, 112p, b&w and color photos, index, glossary, appendices, order no. 1606.

Basic 35mm Photo Guide

Craig Alesse

Great for beginning photographers! Designed to teach 35mm basics step-by-step. Features the latest cameras. Includes: 35mm automatic and semi-automatic cameras, camera handling, *f*-stops, shutter speeds, and more! $12.95 list, 9x8, 112p, 178 photos, order no. 1051.